GREAT RAILWAY JOURNEYS

LONDON TO SHEFFIELD

ROGER MASON

AMBERLEY

First published 2016

Amberley Publishing
The Hill, Stroud
Gloucestershire, GL5 4EP

www.amberley-books.com

British Library Cataloguing in Publication Data.
A catalogue record for this book is available from the British Library.

ISBN: 978 1 4456 3396 1 (print)
ISBN: 978 1 4456 3407 4 (ebook)

Typesetting and Origination by Amberley Publishing.
Printed in the UK.

Preface

I acquired a love of trains at a very early age and I probably have my father to thank for it. One of my happiest childhood memories is being aged around seven and trainspotting with my grandmother at High Wycombe railway station, taking a ride of around two miles in the cab of a steam locomotive – it was at the invitation of the driver and I am sure that he and the fireman risked at least serious censure.

This love of trains led me to write *London to Birmingham by Rail*, which was published in 2013. It was not a technical book about railways, but described forty fascinating things that can be seen from the window of a train during the journey. This book follows the same pattern, and describes forty very interesting things that can be seen from the window of a train making the journey from London to Sheffield. I found them appealing and I have every expectation that you will too.

I visited all forty of the sites described in this book, plus some others that were not suitable for inclusion. I took twenty-nine of the photographs and rather immodestly asked passers-by to take the two that include me. I have to thank my family for the remainder. My wife Dorothy took St Katherine's church, Irchester, and Ratcliffe-on-Soar Power Station, and my grandchildren took the rest. Lauren took St Albans Cathedral and the Triangular Lodge. Hannah took Luton Hoo and Foxton Locks. Charlotte took the two Cardington Hangars and Oliver the Stewartby Brick Chimneys. Esme took the M1 motorway.

This is my twenty-first book and I have greatly enjoyed writing it; I very much hope that you enjoy reading it.

Roger Mason

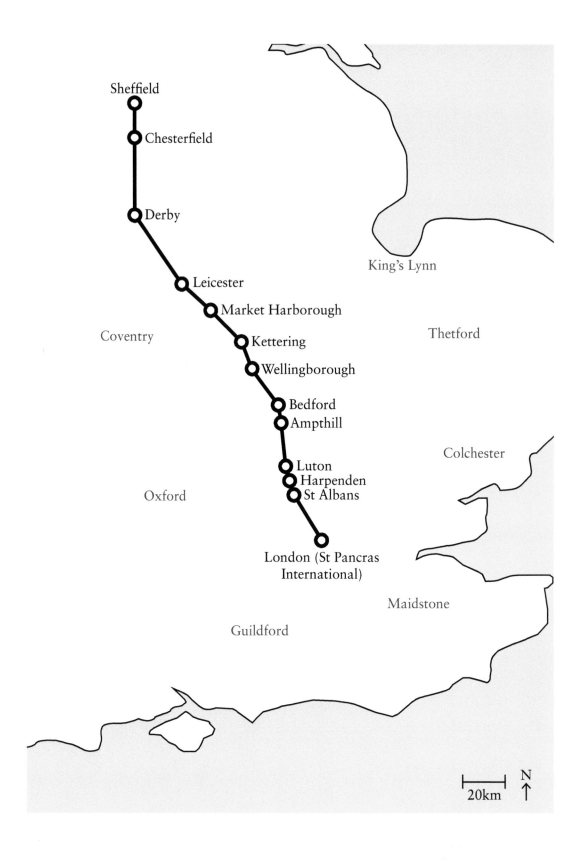

Sheffield

Chesterfield

Derby

Leicester

Market Harborough

Coventry

Kettering

Wellingborough

Bedford

Ampthill

Luton

Harpenden

St Albans

Oxford

London (St Pancras
International)

King's Lynn

Thetford

Colchester

Maidstone

Guildford

N

20km

Contents

St Pancras International Station

St Pancras International is one of three main-line termini situated within a short distance on the north side of the Euston Road in London. It is situated between Euston and King's Cross, which it immediately adjoins and with which it shares an underground station. St Pancras is a Grade I listed building and the best of the three; many would say it is the best of all the London stations.

In my book *London to Birmingham by Rail*, only the first section is devoted to Euston Station. It has a distinguished history, but it was redeveloped in the 1960s and 1970s and is architecturally unattractive. St Pancras International is not like that. It is special and, including the St Pancras Hotel, the first three sections of this book are deservedly devoted to it.

Midland Road runs along one side of the station and this is a very good indicator of its heritage. It was built as the London terminus for the Midland Railway. In the 1850s this company had a network of lines in the Midlands and North, but no access to the capital. This was a serious disadvantage and a temporary solution was implemented in 1857. The company started using the Great Northern's lines into King's Cross, which had opened in 1852. Due to congestion, this arrangement could not last long and in 1862 the Midland surveyed a route from Bedford into London, ending in its own new station at St Pancras. The new line and the new station were opened in 1868.

William Barlow was the engineer for the new station, which immediately attracted much favourable comment. Particularly admired was the glass and wrought iron single-span roof. This was 689 feet long and 240 feet wide, and at the time of its completion was the largest such structure in the world. The previous holder of the record was New Street Station in Birmingham. It is worth looking up at the roof and it is hard not to feel a sense of awe, especially when you remember that it was built nearly 150 years ago. The train shed, being the main part of the station, was and is known as the Barlow Shed. The whole station has been called the 'cathedral of the railways'.

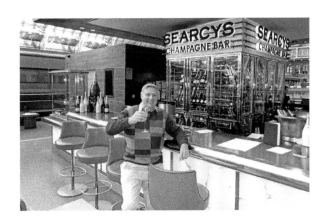

The author enjoying a glass of champagne at St Pancras International Station.

Just outside the terminus the line crosses the Regent's Canal by means of a bridge, and it comes into the station at a height of between twelve and seventeen feet above the natural ground level. This is why, if you approach the station on foot, you will climb up from the Euston Road. The elevation enabled the construction of an extensive undercroft, built with columns and girders. This was used for freight storage, especially of beer brought down from the breweries in Burton upon Trent.

During the twentieth century, the Midland Railway and St Pancras Station suffered troubled times, and endured many trials and tribulations. The Railways Act 1921 forced the merger of Britain's rail companies into just four large groupings. The Midland joined the London and North West Railway (LNWR) in making the London, Midland and Scottish Railway (LMS). The former LNWR seemed to be the senior partner and Euston became the principal London terminus. To add insult to injury (or more accurately injury to insult), St Pancras was damaged by German bombs in May 1941.

Britain's railways were damaged and run-down during the Second World War, and they were nationalised with effect from 1 July 1948. So St Pancras came under the ownership and control of British Railways. Some people, but probably not all that many, look back with fond memories of the period of public ownership. However, almost everyone can agree on two failings. One is the deplorable quality of British Rail sandwiches and the other is the shortage of funds for investment.

In the 1960s the British Railways Board came to the conclusion that St Pancras was surplus to requirements, and there were several attempts to have it closed. So it is not surprising that spending money on the station was not seen as a priority. The attempts to have the station closed failed, thank goodness. We now have a shortage of rail capacity, which is a principal reason for building HS2. St Pancras would have been very badly missed. The following chapter of the book gives details of how St Pancras was saved.

The station was to have a glittering future, but it was underused for many years after the decision was made not to close it. This came to an end when it replaced Waterloo as the London terminus for the Eurostar trains that go to Paris and Brussels via the Channel Tunnel. It is linked to the line by many miles of tunnels and, with respect to any French readers of this book, it is superior to Gare du Nord in Paris.

The Eurostar trains are more than 330 yards long and in order to accommodate them the original train shed was extended by a new flat-roofed structure. It was also extended to serve Thameslink trains into Kent. Trains for Sheffield are operated by East Midlands Trains and depart from the section for platforms 1 to 4.

It appears to be a law of nature that major construction projects vastly overrun their cost estimates. It is almost as predictable as England's footballers disappointing in the World Cup. There are numerous examples, Wembley Stadium being one of them, and details of its problems are given later in this book. The cost of the St Pancras redevelopment was no exception. The initial estimate was £310 million and it came in at £800 million.

A cost overrun of £490 million takes a lot of explaining but, as with Wembley Stadium, we got something very worthwhile for the vast expenditure. The Queen and the Duke of Edinburgh reopened the station as St Pancras International on 6 November 2007. It was quite an occasion and the celebrations included a performance by the Royal Philharmonic Orchestra. Two Eurostar trains and another train appeared simultaneously through a cloud of dry ice and arrived at adjacent platforms.

Much of the undercroft has been filled with shops, including quite a few upmarket and expensive ones. Cafés and restaurants feature prominently. You should not be hungry or thirsty, provided of course that you have the necessary funds.

No account of St Pancras International would be complete without an account of Searcys Champagne Bar. It is the longest champagne bar in Europe and the seating area extends down the side of the platforms from which the Eurostar trains depart. So you have a good view. I paced out the length of the seating area and made it about 90 yards. This is in addition to a substantial indoor drinking and dining area.

A vast array of champagnes was on offer, the cheapest costing £9.50 for a 125-ml flute. The most expensive standard-sized bottle was Krug Clos du Mesnil Blanc de Blancs 1996 at £1,400. Believe it or not, available to pre-order was a thirty-litre Melchizedek at £9,000. Large champagne bottles are named after persons named in the Old Testament. I know that I do not have to tell you that Melchizedek was a king and priest mentioned in the Book of Genesis. To my surprise, the giant bottle was produced for my inspection. I declined an opportunity to hold it as I thought that dropping it would be a very expensive mistake to make.

I felt that I owed it to my readers to sample what was on offer. So just before joining the train to Sheffield I enjoyed a glass of champagne and half a dozen oysters. It was an enjoyable duty and the picture shows me at the bar.

Two Impressive Statues

Unless you are in a hurry, your passage through St Pancras International Station should include a look at two very impressive sculptures. One is named *The Meeting Place* and is

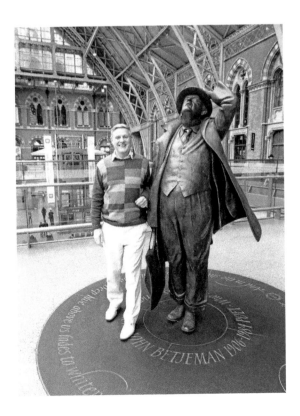

The writer pictured with the statue of Sir John Betjeman at St Pancras International Station.

by the British sculptor Paul Day. The other, by British sculptor Martin Jennings, is a bronze statue of the former Poet Laureate Sir John Betjeman. Unlike *Piscator* by Sir Eduardo Paolizzi, at nearby Euston they can be enjoyed without the effort of working out what they mean. An indication of their popularity is that both are regularly surrounded and studied by passers-by.

You will not have a problem locating *The Meeting Place* because it is more than twenty-nine feet tall. It is at the south end of the upper level, under the famous Dent clock, which is noted for its eighteen-foot diameter and twenty-three-carat gold leafing. The statue depicts a man and a woman locked in an amorous embrace, something that many will find evocative of railway stations through the years. Day lives in France with his French wife Catherine. The embrace depicts the two of them and it is intended to be a metaphor for St Pancras's part in the Anglo-French relationship.

The statue was commissioned by London and Continental Railways and it was inaugurated by the Queen when opening the station in 2007. The high-relief frieze was placed around the base in 2008. This features a number of scenes relevant to train and tube travel, and I found them both impressive and moving. They include people queuing on platforms, people crammed into carriages, soldiers going to war and injured soldiers returning from war. Very controversially one of the panels once showed a person falling into the path of a train that was being driven by the Grim Reaper. This was felt to be too shocking and it was replaced.

The statue of Sir John Betjeman is there because of his leading role in saving the station in the 1960s. It is close to the truth to say that but for him it would have been demolished. The statue is six feet seven inches high and brilliantly captures the appearance and character of the man. Betjeman looks exactly as we remember him from his television programmes. He is wearing a hat, a waistcoat, a tie, a flapping mac, and he is carrying a bag. The expression is pure Betjeman and he is gazing up at the Barlow roof. Martin Jennings did a good job. I am, though, puzzled by the relevance of the lines inscribed on the base, which is a flat disc of Cumbrian slate:

And in the shadowless unclouded glare
Deep blue above us fades to whiteness where
A misty sea-line meets the wash of air.

It is from Betjeman's poem *Cornish Cliffs*. It is a fine poem, but no finer than many others. Furthermore, some of his poems were about railways. Perhaps I am missing something.

Sir John Betjeman was Poet Laureate from 1972 until his death in 1984, and he is probably the best remembered and best loved of the post-war poets. He wrote straightforward lines that rhymed and reflected the feelings of countless people. An example of his poetry deserves a mention in this book. With great reluctance I pass over the claim of the lovely Miss Joan Hunter Dunn and quote the opening lines of *Slough* published in 1937:

Come friendly bombs and fall on Slough
It isn't fit for humans now
There isn't grass to graze a cow

Betjeman later very much regretted his words because, a few years later, Slough was actually bombed.

John Betjeman cared passionately about Britain's heritage, especially its Victorian architecture, and he was a founding member of the Victorian Society. One of his achievements was the successful campaign to save Holy Trinity Church in Sloan Street, London. Not least of his passions was the country's railway architecture. Sadly his efforts to preserve the Euston Arch failed, but his crusade to keep St Pancras Station and the adjoining hotel was gloriously successful.

In *London's Historic Railway Stations* published in 1972, Betjeman wrote that the plan to demolish St Pancras had been criminal folly. He wrote 'What [the Londoner] sees in his minds eye is that cluster of towers and pinnacles seen from Pentonville Hill and outlined against a foggy sunset, and the great arc of Barlow's train shed gaping to devour incoming engines, and the sudden burst of exuberant Gothic of the hotel seen from the gloomy Judd Street'.

Well done Sir John. You deserve the statue.

St Pancras Renaissance Hotel

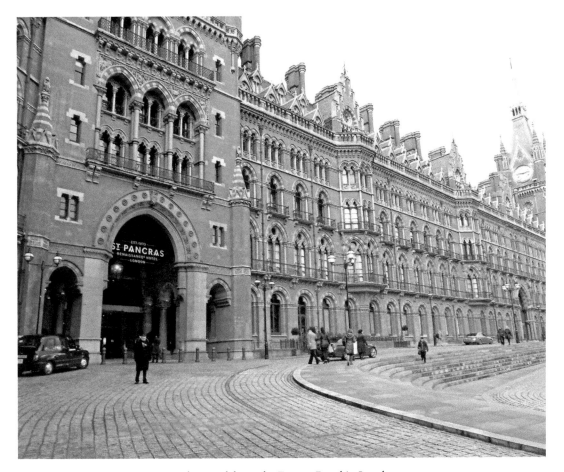

St Pancras Renaissance Hotel viewed from the Euston Road in London.

An appreciation of St Pancras International Station might profitably start with a look at this remarkable five-star hotel, which is the station's frontispiece onto London's Euston Road. It is a Grade I listed building, more than 270 feet tall and a beautifully restored Gothic edifice.

There were obvious commercial reasons for building hotels near to railway stations. The Midland Railway Company was one of the Victorian companies to build substantial ones adjacent to their London termini. By common consent, this was one of the best and many would say that it was the best of all. The Midland Grand Hotel was opened by Queen Victoria in 1873, five years after the station opened for business. It was a signal of honour that Victoria did this for a private company. Although it was twelve years since the death of her beloved Albert, she was still in mourning and undertook few such duties.

The name of Sir Gilbert Scott is inextricably linked with the hotel. He is remembered as one of the country's most famous architects and the founder of an architectural dynasty. It was he who was commissioned to design the building. Sir Gilbert was the father of Gilbert Scott Junior and John Oldrid Scott, and the grandfather of Giles Gilbert Scott. All four were very talented architects. Sadly, Gilbert Scott Junior suffered from mental instability and excessive drinking. Ironically, he died while at the Midland Grand Hotel, the cause of his death being cirrhosis of the liver.

Sir Gilbert Scott is remembered as an English Gothic Revival architect and, among many other things, for the design, building and renovation of churches. A list of his projects is bound to have the hotel at or near the top, and it will also include the Albert Memorial, St Mary's Episcopal Cathedral in Edinburgh and the Foreign and Commonwealth Office. The Midland Grand Hotel was and (under another name) still is a loved example of Gothic architecture. Sir John Betjeman once said that it was too beautiful and too romantic to survive. It did though, and it was largely due to him.

The heyday of the original hotel lasted during the late Victorian and Edwardian periods. As told in the first chapter of this book, the station was run down during and after the First World War and from 1923 it was part of the LMS Railway. The fortunes of the hotel mirrored those of the station and it declined in parallel. In 1935 the hotel closed for business. It was used as offices from 1935 until 1985 when it was declared unsafe and not used at all. In the 1960s its existence was threatened along with the existence of St Pancras Station. As told in the last chapter both were saved.

The original hotel had many features that were innovative for its period. They included revolving doors and lifts but, in common with almost all hotels at the time, there was no running water in the bedrooms. Guests had to enter the corridors and use communal bathrooms. Accounts of the hotel almost always include the grand stone staircase and windows more than 50 feet high.

The renovated and luxurious St Pancras Renaissance Hotel opened in 2011. An extension had been added, giving it a total of 245 rooms. Its many features include the transformation of the station's booking office, which is now a restaurant and bar, the latter being no less than ninety-five feet long. In an elegant tribute to the hotel's heritage, Harry Handelsman the developer said, 'In 1873 London had the most beautiful hotel in the world. I hope that we have given it back to them now.' It all came at a price of course and that price was £150 million, double the projected cost. As already mentioned in this book it seems to be a law of nature that major projects come in over-budget.

I seriously wondered if I owed it to my readers to spend a night in the hotel and report on the experience. I also wondered if it would be a legitimate tax-deductible cost. Regrettably I decided not, though I did enjoy a drink in the bar.

The Burdett-Coutts Memorial Sundial

The Burdett-Coutts Memorial Sundial is in St Pancras Old Churchyard which, in turn, is in St Pancras Gardens. It can be seen from the left-hand side of the train, almost immediately after it has left St Pancras Station. It will be going slowly so you should not have a problem spotting it. The word sundial conjures up an image of a wall-mounted dial or a small column, but this is not what you will see. It is a tall structure, built in the Gothic style. Looking at it from a distance, my first (inaccurate) impression was of a mini Albert Memorial.

The railway is the reason that it is there. When the lines were built they took part of the graveyard for St Pancras Old Church. This meant that the graves and gravestones had to be removed. The obelisk commemorates the people whose last resting place was disturbed. The memorial sundial is Grade II listed and it was unveiled by Baroness Angela Burdett-Coutts in 1879.

The sundial was designed by George Highton and is constructed of Portland limestone, marble, granite and Red Mansfield sandstone. The entirety is enclosed by cast iron railings with Portland limestone statues at each corner. They depict animals, one of which is believed to have been modelled on Angela's collie dog. The metal sundial is at the top of the west face, and integral to it is the Latin text 'Tempus edax rerum', which translates as 'Time, the devourer of all things'. How true these words are. Further down, the west face

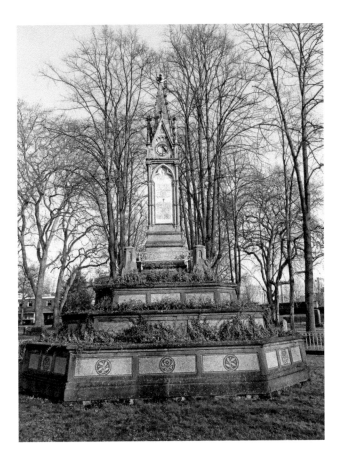

The Burdett-Coutts memorial
sundial.

contains a long biblical quotation from Matthew 5, followed by a prayer and a religious poem. The following, which sums up the purpose of the memorial is on the east face:

> These gardens, formed out of the burying ground of St Giles, and the churchyard of St Pancras, are assigned for ever to the loving care and use of the parishioners. Hereon are inscribed some names, English and foreign, which have an interest for all time. This dial is however especially dedicated to the memory of those whose graves are now unseen, or the record of whose names may have been obliterated.

Seventy-four names follow, extending over the southern and northern faces. It is very unlikely that the names will be familiar now, but at the time some of them were said to be eminent.

Angela Burdett-Coutts was a fabulously wealthy philanthropist. Her father was a controversial and radical politician and her mother, whose maiden name was Coutts, was from the banking family. In 1837, at the age of twenty-three she became, with the exception of Queen Victoria, the wealthiest woman in England. On the death of her step-grandmother she became the beneficiary of a trust fund. The many assets held by the fund included a 50 per cent share in Coutts bank. Her step-grandmother favoured her over her five older siblings. They may well have had expectations and may well have been very disappointed.

She took an interest in a very wide range of issues and she gave her money to a very wide range of good causes. They are far too many to mention or even to summarise properly, but they included providing seed potatoes to impoverished tenant farmers in Ireland and being the co-founder of a school in Westminster. She was a benefactor of the Church of England and, together with Charles Dickens, she founded a home for young women who had adopted a life of immorality.

In 1871 she was created a peeress by Queen Victoria. In 1872 she became the first woman to be made a Freeman of the City of London, and in 1874 she became the first woman to be made a Freeman of the City of Edinburgh. So when she commissioned and unveiled the memorial sundial that bears her name she was very well known and respected.

As can be imagined, Angela, aged twenty-three, single and the second richest woman in England, was pursued by many suitors. Under the law at the time, the property of a married woman belonged to her husband. She turned her back on all prospective husbands and decided that she would live her life as a single woman. She did indeed maintain this intention for much of her life, but her resolve faltered on two occasions.

She formed a very close friendship with the Duke of Wellington, the former prime minister who had defeated Napoleon at Waterloo. They exchanged more than 800 letters. At the age of thirty-three, Angela proposed marriage to the Duke, who was seventy-eight at the time. He turned her down in the most charming way possible, saying that he was an old man with arthritis and that she deserved better. They remained good friends afterwards. Wellington was known for controversial liaisons. He definitely shared one mistress with Napoleon (Marguerite Josephine-Weiner) and probably a second (Giuseppina Grassini), though only when the French emperor was safely detained on St Helena.

Angela must have felt an attraction for men with an age greatly different from her own. When she was sixty-seven she married her assistant, the twenty-nine year old William Lehman Ashmead Bartlett. He subsequently became a Conservative MP. By all accounts it was a happy marriage. Bartlett was born eighty-two years after Wellington.

The memorial sundial is impressive, interesting and beautifully kept. It is worth a visit if you ever get the opportunity. In the meantime, there is much to think about. It is quite a story.

The Regent's Canal

Very soon after the Burdett-Coutts Memorial Sundial, the line crosses the Regent's Canal. It is still close to St Pancras International Station, so the train will still be travelling slowly. The picture is taken from the towpath and shows the railway bridge.

The canal links the Paddington Arm of the Grand Union Canal with the River Thames at Limehouse. It is just over eight and a half miles long and incorporates three tunnels, the longest being the Islington Tunnel which has a length of 969 yards. The route runs along the northern edge of Regent's Park and bisects London Zoo. It is stretching the imagination almost to breaking point, but it could be likened to an inner-London canal version of the North Circular Road. The canal was built before the railway age and a principal objective was to help take goods and materials from the River Thames and North London up to the Midlands. It brought things the other way too, of course.

Work started in 1812 and the first section was completed in 1816. The whole canal opened in 1820 when work on the second section was concluded. Financial difficulties

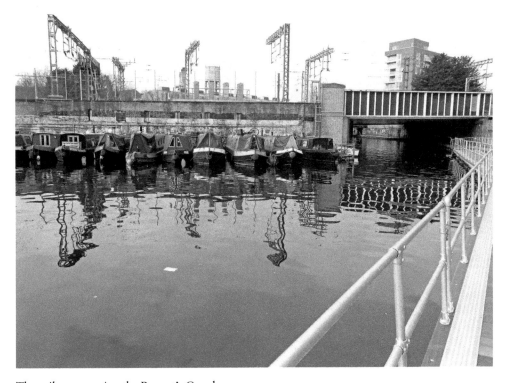

The railway crossing the Regent's Canal.

delayed the construction and these were exacerbated by the embezzlement of funds by Thomas Homer, once the canal's promoter. He was sentenced to transportation. Another drain on funds was the cost of settling a dispute with a landowner.

Building the canal eventually cost £722,000, which was twice the original estimate. As mentioned elsewhere in the early chapters of this book, major capital projects have a habit of costing more than planned. It happened with the redevelopment of St Pancras Station, the renovation of the St Pancras Renaissance Hotel and the redevelopment of Wembley Stadium. It was ever thus. In my book *London to Birmingham by Rail* I tell how Kilsby Tunnel, then by far the longest railway tunnel in Britain, cost £300,000 rather than the projected £100,000.

The Regent's Canal was finished just a few years before the start of the railway age, and this meant that the anticipated profits were short-lived. It was initially heavily used, but commercial traffic declined and virtually ceased by the 1960s. In the nineteenth century, there were serious plans to convert the canal into a railway but, as it is still there, it is stating the obvious to say that they did not come to fruition. In 1927 the Regent's Canal Company bought the Grand Junction Company, and together they became the Grand Union Canal Company. This was nationalised in 1948.

The canal is beautiful in parts and it has been called one of London's best-kept secrets. It is now used by pleasure craft and, in the summer months, a waterbus runs at hourly intervals from Maida Vale to Camden. The towpath is used by cyclists and walkers. Quite a few cyclists also use it for commuting. The London Canal Museum at Battlebridge Basin is worth a visit and so are the Camden Markets, which are located next to the canal. They contain an exciting collection of what seems like hundreds of stalls. Words to describe them would include 'quirky', 'modern' and 'way-out'. Unsuitable words would include 'upmarket' and 'traditional'. The stalls feature a vast array of such things as posters, cards, clothes, shoes, bags and music.

The famous architect John Nash was a director of the Regent's Canal Company, though his assistant John Morgan was appointed the canal's engineer. Nash was a friend of the Prince Regent and he successfully asked his permission to have the company and the canal named after him. The nearby Regent's Park is also named after the prince. It was Nash who built the much loved Royal Pavilion in Brighton for him.

The Prince Regent, George Augustus Frederick, was the eldest son of George III and he ruled as regent from 1811 when his father descended into madness. The Regency lasted until his father's death ten years later, and he then ruled as George IV until 1830. He is fondly remembered as a patron of architecture and as a profligate collector of fine paintings, but history has not been kind to his memory. He was exceedingly extravagant, enormously fat and perpetually burdened by serious debts. He did not rule wisely and he was held in contempt by many of his subjects.

At the age of twenty-three, he went through a form of marriage with Maria Fitzherbert, who was six years older than him and a twice-widowed Catholic. The marriage was illegal because the Royal Marriages Act 1772 required the consent of the monarch. This was neither sought nor granted. Furthermore, the Act of Settlement 1701 prevented the spouse of a Catholic succeeding to the throne.

The parlous state of George's finances were an embarrassment and a scandal, and his father only agreed to help him on condition that he married his cousin, Caroline of Brunswick. His bride horrified him and they separated soon after the wedding. Among many other complaints he thought that she was unhygienic. George had a number of mistresses, both before and after the wedding. He also fathered a number of illegitimate

children. It has been noted that many of his mistresses were grandmothers, so at least he cannot be accused of age discrimination. After nearly a quarter of a century apart, Caroline demanded to take her place as queen at George's coronation. The king's attempt to divorce her failed, but he did manage to keep her away from the coronation. The people very strongly supported Caroline.

On George's death *The Times* newspaper printed, 'There never was an individual less regretted by his fellow-creatures than this deceased King. What eye has wept for him? What heart has heaved one unmercenary sorrow? If he ever had a friend – a devoted friend in any rank of life – we protest that the name of him or her never reached us'.

If you are feeling charitable as you cross the Regent's Canal, you might reflect that Maria Fitzherbert was the love of George's life, and that he died with a miniature portrait of her hanging round his neck. Had their marriage been recognised, his life and his reign might have turned out much better, but of course they might not. We will never know.

Wembley Stadium Arch

The Wembley Stadium Arch can be seen for a period as the train travels past Hendon Station and through north-west London. It is some considerable distance away and it is necessary to look slightly backwards from the left-hand side of the train. It is prominent on the skyline and easy to see. The arch is 440 feet high and it spans the redeveloped Wembley Stadium.

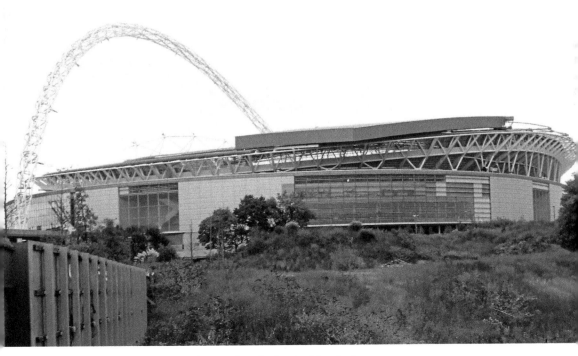

Wembley Stadium showing the 440-foot-high Wembley Arch.

The last match at the old Wembley Stadium was played on 7 October 2000. A disappointing England team lost 0-1 to Germany, and a despondent Kevin Keegan resigned in the dressing room five minutes after the final whistle. The plan was to demolish the old stadium by the end of the year and to open the new Wembley Stadium in 2003, but an awful lot went wrong. As the project progressed, time and cost overruns became embarrassing. Originally budgeted at £326 million, the stadium finally came in at a staggering £797 million, and it was finally handed over on 9 March 2007, in time to host the 2007 FA cup final.

When it was opened most people were pleased with what they had eventually got. There is so much inside the complex that it is a kilometre around the perimeter. The seating capacity is 90,000 and it has a partially retractable roof. Of course there is the famous Wembley Arch with a span of 1,040 feet, which makes it the longest single-span structure in the world. The stadium is said to be the most technically advanced in the world, though there are no doubt some who would dispute the claim. The facilities inside are breathtaking. You should have a brilliant view and (at a price) be very well looked after. The cost can be very considerable. A twenty-seat box on the halfway line for ten years costs £2.4 million. This covers all events at the stadium, but not food and drink.

It is interesting to record some of the differences with the old stadium that it replaced. All 90,000 spectators of course sit in roomy, individual seats, whereas in the old stadium they sat on long uncomfortable benches. There are no pillars, whereas the old stadium had seventeen of them. Perhaps the most notable difference of all is that there are 2,816 toilets compared with just 380 in the old Wembley. The stadium has more toilets than any other building in Britain. Writing as a man who has watched a Wembley match with a restricted view while working out how to get to a toilet, it is a big improvement.

As you would expect, football is the main activity. Each year Wembley hosts the FA Cup final and semi-finals, the League play-offs, the FA Community Shield, the final of the Football League Cup (currently called the Capital One Cup) and all of England's home international matches. There has also been the final of the Champions League and the football finals of the London Olympics. Apart from football there are major Rugby League games, one match each season from the American National Football League's International Series, and sometimes large concerts are held there.

The new Wembley Stadium inherited a mountain of nostalgic memories from the old one that it replaced, and it has much to do to build on its inheritance. The old stadium, famous for its twin towers, was built for the British Empire Exhibition of 1924, and incredibly it was originally intended that it be demolished in 1925. The first event held there was the 1923 FA Cup final, which was not an all-ticket game. The official capacity of the ground was 127,000, but something like double that number crammed inside, with a further 60,000 stranded outside. Photographs show that they were nearly all men and that almost all of them were wearing hats. The scope for a catastrophe was terrifying, but the afternoon passed without incident. Bolton Wanderers beat West Ham 2-0. David Jack scored in every round and got both goals in the final.

The old stadium hosted numerous England international matches, five European Cup finals, the final of Euro '96 and the annual FA Cup finals, including the celebrated one in 1953 when Stanley Matthews put on a dazzling display and Stanley Mortensen scored a hat-trick to win the cup for Blackpool. Other sports using Wembley were Rugby League, speedway and greyhound racing. These last two sports were very popular and regularly attracted enormous crowds.

The 1948 Summer Olympics were held at Wembley. These were the friendly, austerity games and were held at a time of rationing. Some of the British competitors made their

own kit and some took their annual leave from work in order to compete. The highlight of the games was a stunning performance by the Dutch housewife Fanny Blankers-Koen. The pregnant thirty-year-old mother-of-two won four gold medals. She might have won two more if she had not been restricted to competing in just four events.

Perhaps the most memorable event of all was the 1966 World Cup final when England beat West Germany 4-2. The citizens of East London call it the day that West Ham won the World Cup. The team provided the inspirational captain (Bobby Moore), the man who scored a hat-trick (Geoff Hurst), and the man who scored the other goal and was described by Alf Ramsey as a player ten years ahead of his time (Martin Peters). It was the match that produced the most memorable quote in football commentary. As the final seconds ticked away and Geoff Hurst scored his third goal, Kenneth Wolstenholme said, 'Some people are on the pitch. They think it's all over. It is now.'

Apart from sport, in 1975 the American stuntman Evel Knievel jumped a motor bike over thirteen double-decker buses in front of a crowd of 90,000. He crash-landed, breaking his pelvis, vertebrae and hand. In 1985 Prince Charles and Princess Diana opened the Live Aid Concert, which Bob Geldof inspired and did so much to promote. It was widely reported, not always favourably, that Prince Charles seemed to be the only man in the stadium wearing a tie. As an inveterate tie man, I think that His Royal Highness got it right.

I can thoroughly recommend the seventy-five-minute Wembley Tour. Booking details are on the website: www.wembleystadium.com. My review of Wembley Stadium has been favourable, which was not what I expected. I had not previously visited the new stadium and I approached it in a negative frame of mind, caused partly by the delays and the massive cost of building it. However, I was won over; Wembley Stadium is magnificent.

Watling Street

The next photograph shows a road half a mile beyond Radlett station. It is on the left side of the train and parallel to the line. This is part of the Roman road of Watling Street and Roman legions once marched along it. The road can be seen from Radlett station and intermittently for a mile before the line swings off to the right. As was the way with Roman roads, it is straight for a considerable distance, something that is apparent from an ordnance survey map. The Romans marched over hills, not round them. They must have been very fit.

Watling Street was originally a track used by the Britons for hundreds of years before the Romans returned to our island in AD 43. The main part of it connected Canterbury in Kent with St Albans in Hertfordshire, just a few miles north of Radlett.

The Romans took it over, straightened it, paved it and used it to link Dover and Richborough in Kent with London. This generally is the route of the modern A2 road. Watling Street crossed the Thames at a ford near Westminster, then went north-west to a point near Wroxeter in Shropshire. Wroxeter is near Shrewsbury and it was the fourth-largest city in Roman Britain. This generally is the route of the modern A5 road. The Kent coast to Wroxeter is considered to be the route of Watling Street, but roads from Wroxeter into Wales and also to Chester are sometimes taken to be part of it.

The story of the Battle of Watling Street in AD 60 or AD 61 is certainly worth telling. There are inevitably quite a few probables in it, but what follows represents the consensus of opinion. The battle was between an alliance of indigenous British people led by Boudicca

Watling Street at Radlett.

and a Roman army led by Gaius Suetonius Paulinus. The Romans were very heavily outnumbered but won a decisive victory that ended resistance to Rome in the southern half of Britain. A Roman historian says that after the battle Boudicca poisoned herself.

The precise site of the battle is not known, but it is generally accepted to have been on Watling Street and probably in the Midlands. Claims have been made for a number of sites, but the most plausible are Mancetter near Atherstone, High Cross in Leicestershire and Cuttle Mill near Towcester.

The background is that King Prasutagus ruled the Iceni people with the consent of Rome, but when he died his will was ignored. His lands were seized, his widow (Boudicca) flogged and their daughters raped. Another tribe joined the Iceni in a vengeful army led by Boudicca. While the Roman governor was campaigning in Anglesey they destroyed Colchester (Roman name Camulodunum) and sacked London after the Romans had withdrawn. While Boudicca's army attacked St Albans, the governor returned and regrouped his forces. This led to the decisive battle.

If we fast-forward eight centuries, we find Watling Street playing another very important part in our island's story. In 878 Alfred the Great, fresh from burning the cakes, defeated the Viking Guthrun at the Battle of Eddington. The subsequent Treaty of Wedmore required the defeated Danes to withdraw to the northern and eastern parts of England. Danelaw continued in these areas, but not elsewhere.

There are probably more than enough old words in this section of the book, but Welsh Nationalists will love Waecelinga Straet, which is the Roman name for Watling Street. Waecel is possibly a variation of an old English name for 'foreigner'. In the context of the time that meant the Welsh.

The M25 Motorway

The train should go over the M25 motorway approximately ninety seconds after passing through Radlett station, and two to three minutes before it reaches St Albans. The motorway is crossed at right angles, and if you are looking from the right side of the train it is immediately after a high mound (or low hill). If you are looking from the left side, it is immediately after some industrial buildings. These are built on the corner of what was once the Handley Page factory and aerodrome. There is now no sign of this. My attempts to photograph the motorway and railway together from this position failed. Both are, quite rightly, very well fenced. In trying to do so I got scratched and my clothes were marked. Instead the accompanying picture was taken from a nearby bridge.

The book has contained no literary quotations since the statues at St Pancras station, so although the connection is very tenuous I will bring in the opening words of *Pride and Prejudice,* written by Jane Austen in 1813. They are: 'It is a truth universally acknowledged that a single man in possession of a good fortune must be in want of a wife.' Culture and the M25 are not obvious bedfellows, but in the same spirit we could say: 'It is a truth universally acknowledged that one of the world's greatest cities must be in need of an orbital road.'

The story starts as long ago as 1905 with recommendations by a Royal Commission on London Traffic. These included roads similar to what we now call the North Circular and the South Circular. Some evidence to the committee proposed another

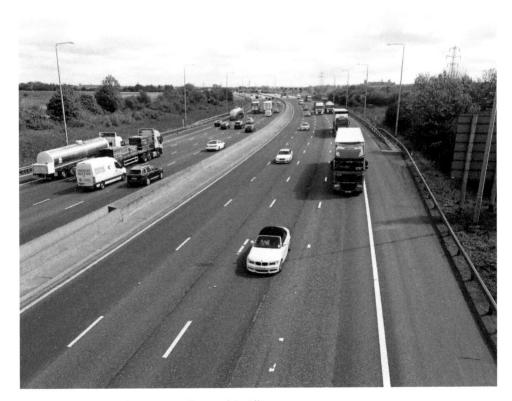

The M25 Motorway between Radlett and St Albans.

ring further out. By 1924 much of the North Circular was under construction and by 1935 streets were joined to form the tortuous South Circular. This was decidedly unsatisfactory because existing streets were linked together, there were many junctions and it did not link with the North Circular in the west. The roads were a far cry from motorway standard. In 1934 there were 2.4 million vehicles in Britain. It is around 35 million today.

The first coherent proposal for a proper orbital road round Greater London was made in 1934 by the Engineer to the Ministry of Transport. It was to be 18 to 20 miles out from Central London, and had many similarities to the eventual route of the M25. There were further proposals in 1944 and up to 1966. None of them were actioned.

The one that was built was announced by the Minister of Transport in 1975 and it was to incorporate some high quality roads that had been built in the early 1970s. The route was 117 miles long and included a new bridge over the Thames, a new tunnel and the utilisation of an existing tunnel. These were technically not part of the motorway. It was opened in sections and the ring was completed in 1986. As you look down on the motorway you may see free-flowing traffic, though it will undoubtedly be busy. On the other hand you may see slow-moving traffic or a complete stoppage. If it is the latter you may understand why it is sometimes called the biggest circular car park in Britain.

It is another truth universally acknowledged that British motorways are not built to an adequate specification, and the M25 was no exception. It was designed for a maximum of 88,000 vehicles per day, but by 1993 it was handling 200,000 vehicles per day. Consequently it has been regularly widened and improved – a process which is continuing. It would have been cheaper and better to have been more ambitious in the first place, but as a taxpayer I can understand why this did not happen.

The M25 has 102 fixed cameras in each direction, both clockwise and anticlockwise. You may be relieved to know that they are not all used for enforcement purposes, though it might sometimes seem like it. In addition there are frequently temporary enforcement cameras because of roadworks. Prosecutions for speeding are becoming harder to avoid because of the sneaky practice of recording average speeds between fixed points. As a law-abiding and safety-conscious citizen you will no doubt welcome this, but it might be hard to be pleased when you open an envelope and find a 'Notice of Intended Prosecution'. I write these words after having driven a quarter of a million miles without an incident and having opened such an envelope this morning.

Having got this off my chest, but still feeling grumpy, I will bring in the Dartford Crossing. This is the Queen Elizabeth II Bridge that crosses the River Thames in a clockwise direction, and the two tunnels that take traffic under the river the other way. The tunnels were open before the motorway was built and the bridge, which carries up to 150,000 vehicles a day, was completed in 1991. Since 2014 it has not been possible to pay the toll in cash at the bridge. Payment must now be made online, by text message, by phone or with a pre-pay account. It is another step in the move to phase out cash and make life more troublesome for us. On a more cheerful note the motorway, which was formerly woefully deficient in service areas, now has four of them. This is just under one every 30 miles on average.

Almost everyone has at least one M25 story and I am no exception. So this chapter ends with an account of the hobby of the father of one of my son's friends. In the early days of the motorway he would frequently drive the complete lap trying to beat his best time. He made it an absolute rule never to break a speed limit. He did this many times, including at night. Sad, isn't it?

The Tower at Shenley

You will not have a problem seeing the tower at Shenley. It is in Shenley village, tall and located at the top of a hill. It comes into view shortly after the train crosses the M25 motorway. The tower is on the right side of the train and it is necessary to look slightly backwards.

The Italianate water tower was built in 1932. It is a remaining part of Shenley Mental Hospital, and it was converted into six duplex apartments in 2005. The view from the top must be stunning. It is surrounded by new housing, the gated Blenheim Mews development. During my visit I formed the opinion that the properties (and the six duplex apartments in particular) would be expensive. They are pleasant, in a pleasant village and in a pleasant area. This and the proximity to London is bound to put the prices out of the reach of many. The Arsenal Football Club Training Centre is nearby, which may or may not be considered a benefit.

The mental hospital was commissioned by Middlesex County Council and opened in 1934. King George V performed the opening ceremony and he was accompanied by

The Tower at Shenley.

Queen Mary. The council already had asylums in Wandsworth and nearby Napsbury, but the expanding population created the need for another one. It was opened fourteen years before the creation of the National Health Service.

Right from the start it was intended that the hospital would be a ground-breaking mental health institution and the King referred to this in his speech. The hospital pioneered a variety of experimental treatments, and research into the causes and treatment of schizophrenia took place. Treatments included malaria fever therapy to cure 'insanity caused by syphilis', electro-convulsive therapy and insulin injections to induce comas. With the benefit of hindsight we can see that some of what was done was very valuable, but that some of it was ill-judged. However, hindsight is a wonderful thing, and it was not available to doctors and nurses at the time. Accounts seem to indicate that they were dedicated professionals doing jobs that many would not want to do.

The layout was different from the traditional large building with wards leading off long corridors. Instead patients were housed in detached villas, with each one containing between twenty and forty-five patients. Some patients were engaged in agricultural or other work, this being considered part of their therapy. Quite a few worked in nearby orchards.

The hospital was built in two stages, with the second stage being completed in 1938. It was big. The accommodation was built for 2,000 but the number peaked at 2,370 in 1953. In the early days there was strict segregation of the sexes. The patients had a variety of mental health problems, but some were admitted because they had epilepsy or were pregnant. A mother and baby unit was incorporated later.

During the Second World War many voluntary patients were discharged or moved out, and the military authorities took over half the hospital. 3,000 wounded servicemen were treated. Two landmines descended on the hospital during a bombing raid. One became entangled in the branches of a tree and did not explode. The other detonated just outside the grounds, causing minimal damage. The German pilot's aim was not very good because they could not conceivably have been aiming at Shenley; the nearby Handley Page aeroplane factory, which was closed in 1970 following the company's insolvency, was perhaps the target. Handley Page factory and aerodrome was right next to the railway line and two miles north of Radlett. There is now no evidence of it and the area is an industrial estate, which can be seen from the train.

In time the focus on treating patients with mental health problems moved to 'care in the community'. The numbers treated at Shenley progressively declined and the last patient was discharged in 1998.

A sad final word in this chapter is given to Dr Jeffreys, who worked at Shenley for twenty years. He said "Of course there was always a stigma about Shenley. It was the case with every county asylum. Children would be warned to watch out and told the men in white coats would be taking them away. If you lived in the area, people would steer clear." Care in the community is not without problems and it is not cheap, but problems such as that have been greatly ameliorated.

Napsbury Park

It is sometimes said in London that it is common to wait a long time for a bus then two come along together, though the observation is unfair on the men and women who work

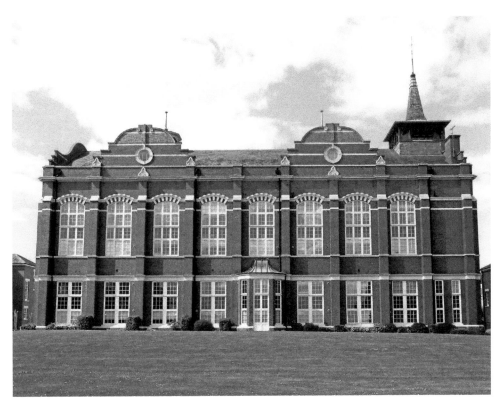

The renovated West Hall of Napsbury Park.

so hard to give London an efficient transport service. Be that as it may, it is extremely uncommon to wait for two former mental hospitals owned by Middlesex County Council then find that two come along together. This is what you will see. Napsbury Hospital was opened in 1905 and closed in 1998. Immediately after the M25 and shortly after looking at the tower at Shenley, you should look forwards on the right side of the train. It is shortly before the approach to St Albans. Part of the remaining hospital building can be seen through the trees.

There are a number of parallels with Shenley. After the hospital was closed, the park, which has a network of footpaths, was made available for residential development. It seems to me that this was very well done. In 2002 Napsbury was listed as a Grade II Historic Park and Garden. It is the renovated West Hall of the hospital building that is shown in the photograph. I preferred the Napsbury housing development to the Shenley housing development, but in both cases the prices will seem expensive to many people. Due to the proximity of their training grounds several Arsenal and Watford footballers live in the area. So if you do buy a property, you may have wealthy neighbours. The Napsbury hospital water tower remains and can be seen from the train. This has been converted to residential use.

The need for a mental hospital arose from the establishment of the London County Council in 1889. A disproportionate number of asylum places were within its boundaries, leaving Middlesex and other surrounding counties short of places. Middlesex purchased the 412-acre Napsbury Manor Farm in order to build the Middlesex County Mental Asylum.

It was designed for 1,205 patients and was opened in 1905. A 600-bed extension was added in 1908. The hospital was designed in the country estate style by Roland Plumbe and the grounds included a farm, kitchen gardens, glass houses and a cricket field. The hospital was supplied by a railway extension from Napsbury.

During the First World War it was known as the County of Middlesex War Hospital. Three hundred and five of the 1,520 beds were retained for patients with mental difficulties, but the remainder of the hospital catered for wounded servicemen. Shortly after the war it was returned to its original use.

It was not too serious but the hospital suffered bomb damage in the Second World War. As land mines fell on the nearby Shenley hospital one wonders if German pilots targeted mental institutions in open countryside. I am no lover of the Luftwaffe but the answer must be no. The pilots must have been totally confused or were aiming at something else, perhaps the Handley Page factory and aerodrome north of Radlett. After all, in the early years of the war British bombs often missed their target by several miles.

The hospital was closed in 1998, but the last patient actually left in 2002.

St Albans Cathedral

The full name of St Albans Cathedral is the Cathedral and Abbey Church of St Alban and it is the oldest site of continuous Christian worship in Britain. The city of St Albans is on a hill and the cathedral is on it. It can be seen by looking forward on the left side of the train as it

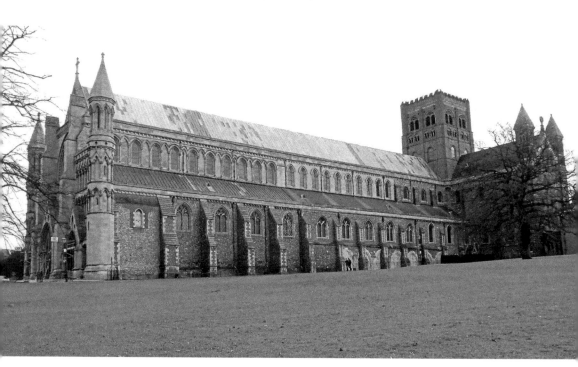

St Albans Cathedral.

approaches the city of St Albans. It does not have a spire but it is clearly visible. It cannot be seen from the railway at the centre of St Albans.

The story and legend of St Alban is more than 1,700 years old so there must be doubts, but it is widely accepted. Around the end of the third century a man called Alban, believed to be a Romano-British citizen, lived in the Roman town of Verulamium. This was within the boundaries of present-day St Albans. He gave shelter to a Christian priest who converted him to Christianity. When soldiers were searching for the priest, Alban exchanged clothes with him which enabled him to escape. The Romans demanded that Alban make offerings to Roman gods, which he refused to do. Instead he proclaimed his Christian faith, and as a result he was beheaded. As a consequence he was accorded the distinction of being a saint. The city is named after him.

A Saxon Benedictine monastery was founded in AD 793 by King Offa, the monarch famous for Offa's Dyke. The present church was begun in 1077, just eleven years after the Norman Conquest, and it was at the time the largest building in England. A small town existed within the abbey's extended boundary walls. Art and literature flourished and the abbey was extremely successful. The present abbey church and gatehouse date from this period.

All good things must come to an end or so we are told, and they did in the late 1530s. The cause was the Act of Supremacy in 1534 that made Henry VIII head of the English church. This was followed by the Dissolution of the Monasteries. St Albans, one of the greatest of them, held out for a while, but the abbot and his community finally submitted. The monastic seal was surrendered on 6 December 1539. The wealth of the monastery had already diminished because Cardinal Wolsey had appointed himself abbot in 1521. He had not been resident, but over nine years he had taken much of the treasure to fund the building of Cardinal College, Oxford. Following the submission in 1539, the rest of the wealth was taken, including 133 ounces of pure gold.

A little later the mayor and corporation bought the abbey church from Edward VI for £400 and it was used as a parish church. In fact, it was the largest parish church in the country. However, the small town and its population could not properly support such a large building, and despite various bequests and the citizens' efforts it progressively declined. The 'Great Storm' of 1797 caused much damage.

The tide of continuous degeneration turned in 1832 when part of the top of the south nave wall collapsed. Various people reached the decision that such a splendid building must be saved. The Earl of Verulam led a campaign which raised £4,000. It was a start but not nearly enough. Fortunately Dr Henry Nicholson became the rector in 1835. He formed a restoration committee and provided strong leadership over a period of thirty years.

Nicholson appointed Sir George Gilbert Scott as architect in 1856. The abbey was the great man's favourite church and he worked on it until his death in 1878. During this time a catastrophe was narrowly averted when the tower almost collapsed, but work to save it was successful. The country's finest eleventh century tower was saved.

Following the death of Scott, a retired barrister, Edmund Becket Denison (later Lord Grimthorpe), arrived on the scene, and this was a decidedly mixed blessing. He was childless and extremely rich, and he gave very considerable amounts of his money to the restoration work. This was extremely welcome, but in return he demanded and was given a great deal of power and influence. He had no architectural training and to put it mildly his ideas did not meet with universal approval. In fact a great number of people condemned them – they liked his money though. It puts one in mind of the old saying

'He who pays the piper calls the tune'. Grimthorpe died in 1905 and he was interred in the churchyard. In addition to the money that he had provided he left a bequest for continuing work.

Of course maintenance, restoration and change continues to this day. Space prohibits too many comments but it should be mentioned that bells have been rung in the tower since the late eleventh century. The Sanctus bell which was cast about 1290 is still in use and now hangs in the south transept gallery.

The abbey church became the cathedral for Hertfordshire and Essex in 1877. It has hosted some notable ecclesiastical figures. Robert Breakspear who died in 1110 was a monk at the Abbey, and was the father of the only English Pope (Adrian IV who held the position for five years from 1154). Robert Runcie was Bishop of St Albans from 1970 to 1980, and Archbishop of Canterbury from 1980 to 1991. He is buried in the churchyard. Although he had been appointed on her advice, it is safe to say that Runcie was not Margaret Thatcher's favourite clergyman. Among other things he annoyed the Conservative government by praying for the dead of both sides after the Falklands War. His remarks deserved respect because he had been a tank commander in the Second World War and had been awarded the Military Cross. He was the only Archbishop of Canterbury in modern times who had killed someone.

The cathedral is usually called 'the Abbey' by local people and one of the city's two railway stations is called St Albans Abbey. It is not on the St Pancras line and trains to Watford run from it.

The cathedral is in the centre of the city and is well worth a visit, by the non-religious as well as the religious. As with almost all places of worship you would be welcome to participate in a service, but of course most visitors do not do that. The building is open from 8.30 a.m. to 5.45 p.m. and admission is free, though a contribution would be appreciated. During a visit you may well feel a sense of history. It is a sobering thought that the first Christian martyr is believed to be buried under the building, and that parts of what you see are nearly a thousand years old.

The building was dedicated in the presence of the King and Queen in 1115. You will notice, or perhaps have explained to you, that the cathedral is an interesting mixture of architectural styles. The nave is 85 metres long (93 yards in old money) and it is the longest nave in England. You will be able to see some remarkable wall paintings, which date from the twelfth century onwards. They were hidden under whitewash after the Reformation and rediscovered in 1862. Another thing to look out for is the Shrine of St Alban. The Chapter House was opened by Queen Elizabeth II in 1982 and stands on the same site as its medieval predecessor, which was destroyed in the Reformation. It provides facilities for the congregations and visitors, and also working space for the staff.

I went to the cathedral with two of my grandchildren, Lauren and Hannah, and it was Lauren who took the photograph. Our visit ended in the cathedral café and as it was just before Easter it seemed appropriate to ask for hot cross buns. We were firmly told that what we were about to receive were not hot cross buns but Alban buns. These originated in St Albans in 1381 and they predate the well-known hot cross buns. These came later and were based on Alban buns, but they are not the same. An Alban bun has an irregular shape and a distinctive spicy taste. The cross on the top is formed with two slices of a knife and there is no piped cross on the top. The cathedral café serves Alban buns during Lent and we returned home well satisfied.

Luton Hoo

This book spotlights three places of interest in the approach to Luton, and as there is one in Luton itself there are four within a relatively short distance. This first one is a treat. It is a manor house hotel with a fascinating history, and despite its proximity to Luton airport and the town of Luton is set in glorious scenery. It is some distance from the train on the left hand side. You will need to look over a very pretty lake and up a grassy slope. It is the rear of the hotel that can be seen and this is what is shown in the photograph.

Luton Hoo is big. The estate covers 1,065 acres, which as you will undoubtedly know is 1.66 square miles. The drive to the hotel from the Harpenden to Luton Road is more than half a mile long and there is a lot of land at the back and the sides as well. There is an impressive formal garden at one of the sides. The grounds host a golf course, a spa and such sports as clay pigeon shooting.

The hotel, which was opened in 2007, is a Grade I listed building owned by Elite Hotels. If you have seen the television programme *Downton Abbey*, you may have a good idea about the interior. Old-world charm and sumptuous are words that come to mind. There are 228 bedrooms and suites, eighty-four of them being within the grounds at Warren Weir. The hotel is a licensed wedding venue.

The matter of cost must be of interest. As with the St Pancras Renaissance Hotel I resisted the temptation to book an overnight stay, but I did make a lengthy mid-morning visit with two of my grandchildren, Lauren and Hannah. It was Hannah that took the photograph. We did not have lunch but the prices on the menu seemed reasonable. We did though have

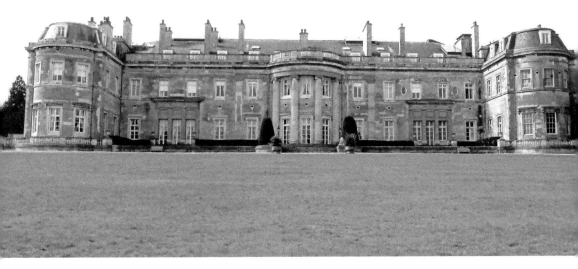

The rear of Luton Hoo.

drinks and food in the lounge and these were of extraordinary value. I ordered coffee and pastries at a cost of £12.50. This turned out to be a cafetière sufficient for four cups, three large cookies and seven delicious pastries. As a single coffee and cake in Starbucks is likely to cost around £4.00 I think that it was remarkable value, and with due respect to Starbucks the seats were more comfortable.

As already mentioned there is a slope up to the hotel and this accounts for both the name of the estate and the name of the family that occupied it. Hoo is a Saxon word meaning spur of a hill and it was in the possession of the de Hoo family until 1523. The last recorded Hoo was Lord Thomas Hoo. His daughter, Anne, married Sir Geoffrey Bullen (Boleine or Boleyn) and was the grandmother of Anne Boleyn. She was the second wife of Henry VIII and mother of Elizabeth I. Being married to Henry VIII was not without risk and Anne was beheaded.

After 1523 the estate passed through a number of hands and in 1763 it was sold to John Stuart, 3rd Earl of Bute. This was Britain's sixth prime minister, who in 1762–63 spent eleven unhappy months in the office. In 1767 the Earl commenced a programme of restoration under the direction of Robert Adam. The work was interrupted by a major fire in 1771 but Bute persevered. After visiting the house in 1781 Dr Samuel Johnson said, 'This is one of the places I do not regret coming to see in the house magnificence is not sacrificed to convenience, nor convenience to magnificence'.

The earl commissioned Lancelot 'Capability' Brown to work on the estate. This was probably Britain's greatest ever landscape gardener, and the man responsible for so many wonderful projects. The prefix 'Capability' which invariably precedes his name does not relate to his capable performance. It arose because he would frequently tell his landed clients that their estates had great 'capability' for landscape improvement. He was responsible for damming the River Lea and forming the two lakes that are part of the Luton Hoo estate and close to the railway line.

In 1825 the leading architect Robert Smirke redesigned the house to resemble its present form, but in 1843 another serious fire destroyed much of the house and its contents. Discouraged, the prime minister's grandson sold the mansion and the estate to John Shaw-Leigh, a Liverpool solicitor. Shaw-Leigh and later his son had most of the building restored and it stayed in their family until 1903.

At this time the mansion and the estate were purchased by Sir Julius Wernher and the glory days began. Sir Julius was born in Germany in 1850, and saw service in the Franco-Prussian war. Following this, at the age of only twenty-one, he moved to London. He made a career in South African diamonds and at the age of just twenty-five was a member of the Kimberley Mining Board. He was very successful and became extremely wealthy, in fact one of the wealthiest men in Britain. In 1888 he married Alice Sedgwick Mankiewicz, twelve years his junior and often known as 'Birdie'. Sir Julius took British citizenship in 1897 and was made a baronet in 1905.

It is believed that Sir Julius bought Luton Hoo largely to please his wife. He was of a retiring disposition and spent much of his time restoring the property and building up his exceptional art collection. His wife was not at all of a retiring disposition and she enjoyed entertaining on a grand scale. Her husband's wealth, willingly provided, enabled her to do this.

The interior of the house was lavishly redesigned in the belle époque style. It was influenced by French chateaux and London's Ritz hotel, which had recently opened. The work was considered to be a triumph and a suitable backdrop for his art collection.

Sir Julius died in 1912 and was spared the agony of the war between his adopted country and the country of his birth. He was also spared the agony of one of his sons being killed

fighting for Britain in that war. His other son, Sir Harold Wernher, later became a major general and his son (the grandson of Sir Julius) was killed in action in the Second World War. The greatly liked and respected Lady Wernher (wife of Sir Julius) used the house less and less after the death of her husband. In 1922 she remarried and moved away.

The house and estate passed into the ownership of Sir Harold who married Countess Anastasia (Zia) Mikhailovna de Torby. She was the granddaughter of Tsar Nicholas I of Russia. Born of a morganatic marriage following the elopement of her mother and father to San Remo in 1891, Lady Zia Wernher brought her own collection of treasures to Luton Hoo, including magnificent Fabergé pieces. These were displayed alongside the treasures that were already there. Horse racing was a passion of Sir Harold and Lady Zia and one of her horses won the Derby in 1966.

During the Second World War, Luton Hoo was occupied by Eastern Command. There were extensive camps in the grounds and a small hospital in the mansion house. Luton Hoo is close to the Vauxhall works in Luton and, during the war, tanks made there were tested in the grounds. After the war Sir Harold and Lady Zia returned to the house and their art collection was opened to the public in 1951. It became a major attraction.

In June 1948 Sir Winston Churchill visited Luton Hoo. He was a Conservative politician and leader of the opposition to Clement Attlee's Labour government, but in many ways he had become a national institution above politics. He came to meet the people and thank them for what they had done in the war. It is claimed that Sir Winston addressed a crowd of 110,000 people. Photographs show an ecstatically beaming Churchill speaking to a vast crowd, but nevertheless 110,000 takes a lot of believing. Think of a full Wembley Stadium then add 20,000. Was it really that size? I doubt it. Nevertheless, the crowd was very big and the event was a great success. A plaque commemorating the visit can be seen on the front of one of the columns of the portico, and there are photographs inside the house.

Sir Harold Wernher died in 1973 and Lady Zia died in 1977. The estate passed to their grandson Nicholas Phillips. Sadly the Wernher connection ended in 1991. Nicholas died at the early age of forty-three, and it was at the time that a business park that he was developing was a victim of the recession. As a consequence the estate was put up for sale and it was purchased by Elite Hotels in 1999. They developed it as already described. It is a lovely place, well worth a visit. If you do, please order the coffee and pastries. They are delicious and excellent value.

Luton Airport

The photograph shows the control tower at Luton Airport and this can be seen on the right side of the train shortly after Luton Hoo. The proper name is London Luton Airport, which to me at least seems cheeky because it is 35.1 miles from Charing Cross, London. Be that as it may, it is the UK's sixth busiest airport and London's fourth busiest, after Heathrow, Gatwick and Stansted.

For many readers, especially the older ones, the two words 'Luton Airport' are bound to bring back memories of one of Britain's most famous and successful series of advertisements. They were for the drink Campari, featured Lorraine Chase and Jeremy Clyde and made in the 1970s. Each was filmed in an exotic location and the suave and sophisticated Clyde would romantically offer Chase a Campari and soda. She preferred a

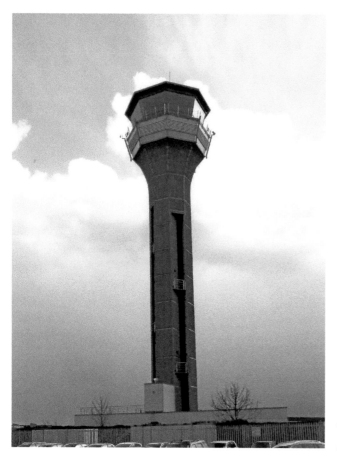

The control tower at Luton Airport.

Campari and lemonade, which led him to say 'Were you truly wafted here from paradise?' The immortal reply from the cockney Lorraine was 'Nah, Luton Airport.'

The airport was opened on 16 July 1938 by the Secretary of State for Air, Kingsley Wood. It was and is owned by Luton Borough Council, but soon after the opening it was taken over by the RAF and it served as a fighter base in the Second World War. After the war it was returned to the council. The airport prospered and by 1972 it was believed to be the most profitable in the country. There was, though, a temporary setback in 1974 when the tour operator Clarksons failed, together with its holiday operator Court Line.

There was a decline in the 1980s. This was caused by the expansion of Stansted and the failure to make necessary investment. This was put right and major infrastructure improvements included a new control tower (the one that you can see), updated air traffic control systems, a new automated baggage handling facility and a new cargo centre. A new departure hall was opened in 2005.

Two major additions opened in 1999, the first being Luton Parkway Rail Station. You will pass through this. The other was a new passenger terminal, which was opened by the Queen and Prince Philip. Needless to say the ubiquitous duty free shops, other shops, restaurants and cafés are there in abundance. They seem to do good business, including with me when I use the airport. My belief is that holiday money is not the same as real money and may be spent with impunity. The holiday and holiday money start when I get to the airport.

In 1997 the council agreed a thirty-year concession to a public/private consortium. In 2005 this was acquired by Airport Concessions Development Ltd, which is owned by two Spanish companies. Ownership is still with Luton Borough Council.

The airport operates with a single runway which is 7,087 feet (1.34 miles) long. It has a hilltop location at the end of the Chilterns, and there is a 130 feet drop at the western end of the runway. The planes have a habit of not running off the end, which is just as well. Easyjet, Monarch Airlines and Thomson Airways have their headquarters at Luton and the airport is used by a number of other airlines. 2014 was a record year and there were 10,484,938 passenger movements. Budapest was the most common destination accounting for 428,056 of them. Since the rundown of Vauxhall Motors the airport has been the town's biggest source of employment. It is interesting to note that Luton is believed to have more taxicabs per head of population than any other town or city in the UK.

A plan to build a second runway has been shelved. Instead it is intended to extend the one existing runway to 9,843 feet (1.86 miles) and to increase the length of the taxiway. This will enable larger planes to use it and reduce the need for taxiing aircraft to cross or move along the runway. More passenger movements will be possible.

The short-term car park next to the terminal is in great demand and is very closely monitored by its operator, APCOA. This is understandable but the company is capable of acting in a ludicrous manner. I know this because I have been a victim of its behaviour. I stopped the car to read a notice and subsequently received a parking enforcement notice for allegedly parking in an unauthorised place. This ridiculous claim was supported by two photographs timed at eleven seconds apart. I appealed to POPLA (Parking on Private Lands Appeal) and the company chose to pursue the allegation. They then produced a photograph of the roundabout close to the car park's entrance. It showed three vehicles with spaces of about 20 yards between each. APCOA claimed that this was evidence that my 'parking' had caused a traffic hold up outside the car park. Needless to say my appeal was successful. I am still waiting for an apology from APCOA.

What did Mr Bin Laden want to achieve when he organised the 9/11 attack on the twin towers and other atrocities? No one is sure but I can only think that he did it just because of his hatred of the West and of the United States in particular. It is sometimes said that he did not achieve anything, but sadly that is not true. He achieved serious and expensive inconvenience to millions of people every day. We have to check in at airports about an hour earlier than was formerly the case, and we then have to submit to extensive and wearying security checks. It is not just at airports, the same thing happens at museums, stately homes and many other places. In my experience, the security staff at Luton and elsewhere are invariably pleasant and efficient, but it adds to life's miseries. It is a depressing thought with which to end this chapter.

Vauxhall Motors

Vauxhall Motors factory and head office can be seen on the left side of the train shortly after it passes Luton Airport. It was once one of the largest industrial complexes in Britain, but its size and scale of operations are now much reduced. The location, which is still the head office of the British company and operations, now employs around 900 staff and

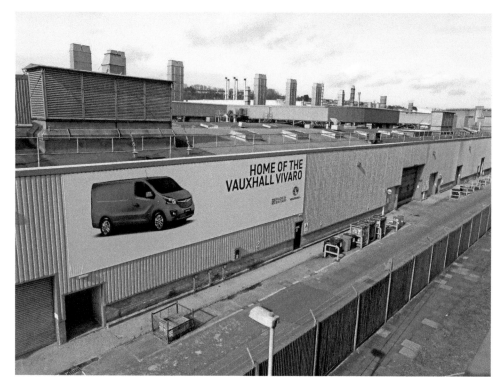

A view of Vauxhall Motors plant.

produces the Vivaro light commercial van. Production at the original car plant stopped in 2002 and the site will soon become the Napier Park Housing Estate.

The company's name gives a very good indication of its heritage and original location, which was the Vauxhall area of south London. In 1857 the firm of Alexander Wilson and Company was founded at 90–92 Wandsworth Road, Vauxhall, to manufacture steam engines, pumps and refrigeration plant. The business prospered and it became a limited company in 1892. However, a receiver was appointed in 1896 and in 1897 the company became the Vauxhall Iron Works Company Limited.

The first car was manufactured in 1903. This was a five-horsepower, single-cylinder model. It had two forward gears, no reverse gear and was steered with a tiller. During the first year about seventy were made, and then the model was improved by the addition of a reverse gear and the replacement of the tiller by a steering wheel. One of the oldest cars, a tiller-steered model, regularly participates in the London to Brighton Veteran Car Run.

Space soon became a problem and in 1905 most of the production was transferred to its present location in Luton. The original site covered six and a half acres though at first it was not all utilised. The number of people employed was initially about 160.

During the First World War the company made many vehicles for use as staff cars for the British forces. Afterwards it continued to make good cars, but its manufacturing methods were outdated and it struggled to compete with its rivals. Consequently the company looked for a strategic partner, and in 1925 it was taken over by the American company General Motors. This must have been a major culture shock because General Motors was one of the world's biggest companies. General Motors owns Vauxhall to this day. The size

and significance of General Motors can be gauged by the saying 'What's good for General Motors is good for America'. Many people would disagree of course.

With considerable success the new owners set about changing things for the better. In 1930 the low-cost, two-litre Vauxhall Cadet was introduced and in 1931 the first Bedford truck appeared. The Cadet was the first British car to have a synchromesh gearbox.

During the latter part of the 1930s there was a big increase in the number of people employed, and much of it came from people who relocated to the area. In this respect it had much in common with towns such as Slough and Corby. Vauxhall was prospering and recruiting at the time when the country was still feeling the after-effects of the depression.

Many of the new workers came from Scotland and in his book *The Vauxhall and Bedford Story*, Richard Hart mentions one man who walked all the way from Glasgow to get a job. They were tough in those days, or at least some of them were. One consequence of the influx was that a number of Scottish societies and Presbyterian churches were established. I think that in our more irreligious times this would not happen now.

During the Second World War Vauxhall was primarily engaged in the production of armaments. When the war started the British army did not have nearly enough tanks and Vauxhall was instrumental in rectifying the deficiency. Over 5,600 Churchill tanks were produced, many of which were tested at Luton Hoo just a few miles down the road, something that is mentioned in a previous chapter of this book. There was other war work too and the company made 95 per cent of the parts for Britain's first jet engines.

Other Luton factories were also engaged in war work and the town was a prime target for the Luftwaffe. During bombing raids 107 people were killed in Luton and more than 500 injured. The large Whipsnade Lion is carved into the Dunstable Downs just a few miles from Luton, and its solid white shape is unmissable. It might as well have been a sign to the bombers saying 'VAUXHALL THIS WAY'. Consequently it was covered for the duration of the hostilities.

Passenger car production resumed in 1945 and methods were more geared to volume than had previously been the case. Over the years a variety of models followed. Their names, which may well be familiar, included Velox, Wyvern, Viva, Victor, Vectra and Cavalier. A manufacturing plant at Ellesmere Port in Cheshire opened in 1962. This initially supplied components to Luton, but passenger car production started in 1964. It now employs more people than Luton and manufactures more vehicles than Luton. The number of employees at Luton peaked in the 1960s at 28,000.

During the 1960s Vauxhall acquired an unfortunate reputation for making vehicles that were prone to rust. Corrosion protection was improved, but the reputation dogged the company for a number of years. After a poor start to the 1970s the company's market share increased and by the end of the decade it was starting to close in on the market leaders, Ford and British Leyland.

There were no major strikes between 1920 and 1950, though there were some lesser ones. In the 1920s union membership was not tolerated and if it was discovered that a worker was a union member, he (usually) or she would be sacked. Some union members joined the general strike in 1926 and they were not all taken back when it finished.

Industrial relations deteriorated in the 1970s, which was a bad decade for strikes in numerous places. An indication of the strength of the unions was a threatened strike in 1976. The threat resulted in a security guard being moved because he was too good at preventing pilfering. All this culminated in a massive three-month walkout in 1979. In recent years industrial relations have been generally good.

Like many manufacturing companies Vauxhall had a summer shutdown, and I recall it causing me some problems. Many years ago I was a manager in a manufacturing company not far from Luton, and we too introduced a summer shutdown. My problem was that our period was not the same as Vauxhall's and several women would not accept ours because their husbands worked for Vauxhall. Despite the fact that we paid equal pay for work of equal value I was firmly told that husbands came first and that they would leave if I insisted. Needless to say I had to give in. I was quite cross at the time, but of course I now realise that I was being unreasonable, or at the least unrealistic.

At the time of its heyday Vauxhall at Luton had a thriving recreational club. Workers participated in many sports and there were numerous other activities. The Vauxhall Concert Orchestra was formed in 1934 and it performed every week in the canteen, and at outside venues. Many stars performed at its concerts, including six-year-old Julie Andrews. Among the others were Max Miller, Gracie Fields, Tessie O'Shea and Sir Adrian Boult. A theatrical section put on three shows a year. An art exhibition featured 500 pictures by employees, including five by the managing director, Sir William Swallow.

Luton old-timers have fond memories of many special occasions. Richard Hart's book mentioned earlier in this chapter is packed with photographs of large groups of people having a good time. My favourites are of almost a thousand children departing to see a pantomime on a fleet of double-decker buses, and a hall packed with hundreds of children enjoying one of the season's three Christmas parties. Each child is neatly labelled.

Luton Town Hall

Luton Town Hall is a white building that incorporates a distinctive white tower. It is in the centre of the town, and from Luton station it can be seen on the left side. It is rather a nice town hall and the people of Luton are probably pleased with it. The town's war memorial is immediately in front and sadly, as is so often the case, it lists a distressingly long list of names. Interesting as it is, the present building can only pale into insignificance when compared with the fate of its predecessor. This is because the original town hall was burnt down at the climax of a riot on 19 July 1919. Much of the information that follows is taken from *Where They Burnt The Town Hall Down* by Dave Craddock, published by the Book Castle.

Ironically the date in question was Peace Day. This was a national day of celebration called to mark the signing of the Versailles Peace Treaty that formally ended the First World War. This had been done on 28 June, but planning the celebrations had taken place over several months. The events in several towns and cities were marred by demonstrations, but what happened in Luton was by far the worst.

Luton, like many other places, contained numerous seriously disgruntled people. One of several causes of resentment had been dissatisfaction during the war with the operation of the local Food Control Committee. Many had thought that it was acting in the interests of the food distributors rather than the community at large. The resentment had led to a strike in the town.

1919 was a year of major industrial unrest in the country and there were many strikes, including some really big ones. Discharged servicemen felt that they were not receiving the pensions that they deserved and had been promised. During the December 1918 election

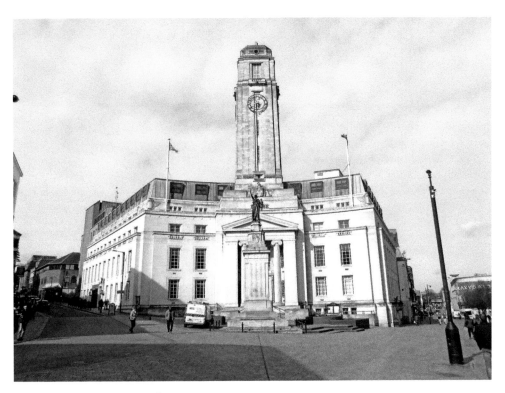

The present Luton Town Hall.

campaign the government had promised to provide a 'Land Fit for Heroes' and there was not much sign of it. The ex-servicemen had voted for 'Homes for Heroes' and some of them thought that they had voted to hang the Kaiser. Homes were in short supply, there were few jobs available and the former German emperor was living safely in Holland. So the town contained a lot of unhappy people.

The council had started planning for Peace Day in February. It was decided that there would be a procession, the decoration and illumination of the Town Hall and Corn Exchange, the illumination of Wardown Lake, a firework display, concerts, sports, a subscription banquet and souvenirs for the children. It was quite a list and an obvious question was how the cost of £500 was to be funded. It now seems an incredibly small sum of money, but £500 went a great deal further in 1919. The decision was that it would be financed by a special halfpenny rate, with any further costs and the cost of the fireworks raised by public subscription. Later a local company generously funded the fireworks in addition to subscribing a sum of £100.

Three national ex-servicemens' associations had branches in the town. The most influential was the National Federation of Discharged and Demobbed Sailors and Soldiers. This was known as the DS and S and it had about 1,500 members. The DS and S had links to the Liberal Party. Another was the Comrades of the Great War, which had links to the Conservative Party. This had about 2,000 members, but it was not as well organised as the DS and S. The third and smallest was the National Association of Discharged Sailors and Soldiers, which had links to the Labour Party and the Trade Union movement. The three associations felt that they had very little influence in planning the great day, and matters

were complicated by the fact that they did not get on with each other. In particular, relations between the DS and S and the Comrades were so bad that they amounted to enmity.

In the run up to Peace Day a number of matters divided the council and the ex-servicemen, and the cost of the various proposals was often an issue. The council planned to have a men only dinner in the evening. Councillors, council officers and friends of the Mayor would not pay, but 'gentlemen' would be able to apply for tickets at a cost of 15s each. Ex-servicemen, who had done the fighting, were gentlemen. They were affronted and so were many women who were excluded.

The ex-servicemen were unhappy with the number of their members who would take part in the procession. The councillors agreed to increase the number, but it was still not as many as they wanted. The children's events were switched to a separate day and cost was an issue. Some felt that various unspent funds, contributed to good causes during the war, should be utilised.

The DS and S proposed to hold a Drumhead Meeting on a separate day. This was to be at Luton Hoo but at a late stage the ex-servicemen asked for the venue to be switched to Wardown Park. The Council would not agree and this rebuff probably caused more resentment than any of the other problems. A national decision of the DS and S was to take no part in the Peace Day celebrations as a protest at the inability of discharged servicemen to find work. The Luton branch decided to adhere to this and withdrew their men from the procession. The Comrades made the same decision, but later changed their minds because to withdraw would not show respect for the fallen.

On 28 June there was an ugly foretaste of things to come. This was the day that the Versailles Peace Treaty was signed, and at 3.50 p.m. the mayor read the official proclamation from the balcony of the Town Hall. Shortly afterwards some young hooligans threw fireworks into the Red Cross Band, which was forced to stop playing. Fireworks were also thrown in front of horses and one landed in a pram, slightly injuring the occupant.

The story now moves to its climax, but at this point it is worth mentioning that the majority of ex-servicemen were not involved in the riot. It was the familiar story of the majority being let down by the minority. It should also be said that the ex-servicemen's leaders were not involved. Many of the rioters were Lutonians not directly connected to the ex-servicemen, and numerous ex-servicemen were not members of any of the associations.

Rain is very welcome for people fearing a riot and it rained all day on 19 July, but it did not prevent what happened. The procession moved off at 2.00 p.m. The Comrades had the front float and 600 children cheered the procession past then joined the rear. The column generally got a good reception, but at one point it passed a DS and S banner which read 'We do not want Processions, we want work'. The DS and S people with the banner booed the Comrades' float and the Comrades as they went past.

The front of the procession stopped at the Town Hall where the mayor read a message from the king and a further one from himself. The king's message was respectfully heard, but the mayor's message was received with a mixture of cheers and boos. A little later another part of the procession halted and the mayor again read the king's message. Once again this was heard respectfully, but because of the jeering and booing he had to abandon his own message. At this point the mayor, the town clerk and some councillors retreated into the building.

After the whole procession had gone past a crowd surged in front of the Town Hall. A group of men rushed up the Town Hall steps, but four policemen guarding the door were able to prevent them getting in. At this point word reached the policemen that another officer had been attacked and was in serious trouble. Two of the four moved away to go to his assistance, and the remaining two could not prevent the mob forcing its way into the building.

The intruders were looking for the Mayor, but with his companions he was locked in the Mayor's Parlour. Unable to find him the intruders moved around the building vandalising the interior. This culminated in them throwing furniture off the Town Hall balcony. Eventually police reinforcements arrived and they managed to clear the building.

Wrongly believing that the mayor was not in the Town Hall a group of about 500 went off to the mayor's house. On arrival a policeman told them that the mayor was not there, and he took a rioter inside so that he could confirm the truth of what he had said. This was duly done and the group moved back to the Town Hall. At 6.30 p.m. the President of the DS and S addressed the crowd and asked it to calm down. A similar message was given by the town's first Labour Magistrate. This had some effect and part of the crowd moved away.

During all the commotion, 20,000 or so had been enjoying sports and celebrations in a local park, many of them unaware of what had been happening in the town centre. Due to the wet conditions the firework display was disappointing and at 9.30 p.m. a crowd of about 4,000 gathered near the Town Hall. This time the mood was really vicious, worse than in the afternoon, though that had been bad enough. Drink was a contributory factor. The Mayor and others were still in the Mayor's Parlour, but they managed to escape through the rear of the building. The Mayor did so wearing a Special Constable's uniform.

The Chief Constable had at his disposal fifty-two regular policemen (four of them mounted), and twenty special constables (one mounted). They performed with great courage and distinction, and there were injuries on both sides. There were no deaths but a police horse was stabbed and had to be destroyed two days later. During the fighting some rioters managed to get inside and lit a number of fires. Firemen arrived but they were attacked and had to withdraw. More rioters subsequently got inside and one man poured petrol on the flames. The firemen returned and were attacked again. They did their best, and it was a good best, but by 4.30 a.m. the Town Hall was completely destroyed. During the night shops in the surrounding area were looted.

The brave policemen were overwhelmed, but later police from surrounding constabularies provided reinforcements. Due to the intervention of the town's MP, troops were drafted in and they arrived at 3.00 a.m. This was decisive and the riot was brought to an end. However, there were further riots on the evenings of the next two days. These were not so serious, but on 20 July it took a full-scale police baton charge to disperse the mob.

After 21 July Luton returned to a state of peace, but it is not right that this chapter should now finish. Still to come are further details, accounts of what followed and finally an editorial judgment.

It was generally agreed that the police had acted with great distinction in the face of terrible odds and provocation. Forty-eight police officers were treated for injuries, which was well over half the number on duty. Five of the injured policemen were detained in hospital. The firemen too had served with distinction and bravery. Nineteen of them attended the blaze and fourteen of them were treated for injuries.

The Town Hall was not insured and there was an obvious financial cost. The Borough rate for 1920 was £28,202, whereas the figure for the previous year had been £15,231. The war memorial that stands in front of the present Town Hall was unveiled on 10 December 1922. The replacement Town Hall, which is the one that you can see from the train, was not completed until 1936.

The mayor, Henry Impey, suffered terribly. He was a decent man who had given much service to the town. He was, though, rather weak and too anxious to please. A number of people appear to have unfairly decided that he should be the scapegoat. On the advice of

the Chief Constable he and his wife left the town in the early hours of 20 July. His wife had a nervous breakdown and his health suffered too. They lived the rest of their lives away from Luton. Rather poignantly Impey, who died in 1930, was buried in the town.

At the invitation of the greatly respected Lady Wernher, the Drumhead Service was held at Luton Hoo on 16 August. This was the service that could not be held in the park and which had caused so much ill feeling. It was a great success and the DS and S and the Comrades cooperated happily. What a pity that they could not have done so before. 9,000 children had their celebrations during two days in September. These too were a great success.

Thirty-nine alleged rioters appeared before the Luton Magistrates. The number seems low, but there were great difficulties in identifying and prosecuting those at fault. They did not have CCTV cameras in 1919. One was discharged, ten were convicted and sentenced by the magistrates, and twenty-eight were committed for trial at Bedford. Nine of the twenty-eight were subsequently acquitted, while eighteen men and one woman were found guilty of at least one charge. All the eighteen men had served in the war and ten of them had been injured. The sentences were lenient, the most severe being three years penal servitude. Many got three months imprisonment or less. One jovial fellow accepted his sentence by wishing the judge a merry Christmas.

The way that the country viewed the people of Luton was brought home to some of them when they had to rearrange their summer holiday arrangements. A number of seaside landladies cancelled their bookings because they did not want to take the risk of having such potentially dreadful people in their lodgings.

At the beginning of this chapter I mentioned that much of my information comes from the book *Where They Burnt The Town Hall Down* by Dave Craddock. It is a splendid book, but I must take issue with one of his conclusions. He says that the town council must shoulder the larger share of the blame. I beg to differ. The council was certainly short-sighted, mean-spirited and made mistakes, but surely the main responsibility for the riots must lie with the rioters. There were hundreds of them, perhaps more, and they were supported or watched by thousands of others. They were all a disgrace to the town of Luton. Furthermore, those of them that were ex-servicemen were a disgrace to their dead comrades and the uniforms that they had once worn. That's my view anyway.

The M1 Motorway

The M1 motorway can be seen on the right side of the train as it runs through North West London. The first sight is at Hendon and it is there almost continuously until open countryside is reached. Shortly after this it crosses the line and swings away to the west. It can be seen on the left for a while shortly after Luton, then the routes of the line and the motorway diverge shortly after Toddington service station. For most of the rest of the journey the line is several miles to the east of the motorway, but it crosses to the west shortly before Derby.

The M1 is 193 miles long, and it connects London and Leeds. It was the first motorway to be completed in Britain and it was opened in four stages. Britain came to motorway building rather late and behind many countries. Hitler beat us to it by a quarter of a century, though his German autobahns were not of motorway standard. However they were of a very high standard for their time. It is a myth that Hitler's primary purpose was

The M1 at Toddington.

to enable troops to be moved swiftly. The main purposes were for propaganda and to help solve Germany's unemployment problem. Both aims were achieved.

The first section of the M1 was opened on 2 November 1959, and together with two spurs it ran from what is now Junction 5 (Watford) to what is now Junction 18 (Crick/Rugby). The extension from Rugby to Leeds was built between 1965 and 1968. Extensions into London were completed in 1966, 1967 and 1977, and it now meets the North Circular Road at Staples Corner.

If you have read the chapter on the M25 you may recall that it was built to an inadequate specification, but that it has been regularly widened and improved, and that this is continuing. These comments followed a very tenuous link to Jane Austen. Exactly the same observations may be made about the M1; in fact they may be made with greater force. However, as the first stage was built nearly thirty years earlier they are more understandable. The actual construction of the first stage (as opposed to the planning and the arguing) was accomplished at the remarkable rate of a mile a week. There were three lanes in each direction and a strengthened hard shoulder. Planners had estimated that usage would be 20,000 vehicles per day. As this is 10,000 in each direction and as there are 1,440 minutes in a day, it presumed an average flow of seven vehicles per minute.

Films, photographs and accounts of the early days show a world that we now find hard to recognise. For a start the road almost always contains very few vehicles. The motorway

gained much interest and photographs often show groups of people gathered on bridges watching the vehicles passing underneath. Families made weekend visits to watch, rather as we might now go to a garden centre. The cars of the time were not designed for the speeds that could be obtained on the motorway and breakdowns occurred at a rate that we would now find inconceivable.

By modern standards the M1 was dangerous. There were no central barriers, no lighting and no speed limit. Seat belts were almost unknown. There were regular appalling smashes when vehicles, especially lorries, crossed the central reservation and hit vehicles coming the other way. Two cars each travelling at 70 mph have an impact speed of 140 mph. Racing cars were tested at dawn and sometimes reached speeds of 150 mph.

The planners and the government got some things wrong to a comical extent. They still do. For a start they thought that the service areas would be very little used. The first two of them were Watford Gap and Newport Pagnell. It was intended that Watford Gap would be for lorries only and that Newport Pagnell would be for cars only. Fortunately they saw sense before the motorway opened.

Two of the service stations can be seen from the train. The first is London Gateway, which is visible as the train leaves North West London and reaches open countryside. It is on the right side immediately after a prominent Ramada hotel. It was opened as Scratchwood in 1969, but its name was subsequently changed. It was not remotely up to Luton Hoo standard, but I enjoyed a snack while researching this book. It is an amusing piece of trivia, but you might like to know that both forward gun turrets on the museum ship HMS *Belfast* (moored in central London) are trained and elevated on the London Gateway Services Area. I do not think that they will ever be fired, but it would not be a good place to be. The second service station that can be seen is Toddington. This is on the left side of the train after Luton.

The M1 was the scene of extraordinary events on 6 September 1997, the day of the funeral of Diana, Princess of Wales. It was the time that much of the population dissolved into paroxysms of grief. Sections of the northbound carriageway were closed to allow her funeral procession to travel from London to Althorp in Northamptonshire. In many areas police allowed pedestrians onto the carriageway to pay their respects, and crowds gathered on bridges and at service stations. Flowers were thrown onto the cars.

Stewartby Brick Chimneys

The four Stewartby brick chimneys are fairly close to the track and in a line roughly parallel with it. They are just over half way between Flitwick and Bedford, and on the left hand side. They can easily be seen and are after a tunnel and shortly after a wind turbine, which is also on the left hand side.

The Stewartby chimneys are almost the only reminder of the Marston Vale brick industry. A person of a certain age who grew up just twenty miles away (I qualify on both counts) will have memories of a vast industry. At its peak Marston Vale, of which Stewartby was a major part, contained 167 brick chimneys. Now just four remain.

In the 1970s Bedfordshire produced 20 per cent of England's bricks and Marston Vale contributed most of them. A large fleet of lorries took the bricks away each day and were a very familiar sight on local roads and beyond.

The four brick chimneys at Stewartby.

Stewartby was once the largest brickworks in the world, manufacturing 500 million bricks a year and employing more than 2,000 people. It boasted the world's largest brick kiln. Smoke belched from its chimneys and from nearby chimneys, and a strong smell of sulphur hung over the area. The prevailing wind took this to the M1 Motorway which is not far away. It was common to see cars pulled on to the hard shoulder because their drivers believed that the sulphur smell in them was caused by their engines overheating. The vale contained many large and deep clay pits which made the landscape appear desolate. From the 1970s exhausted pits began to be used for landfill purposes.

The clay was rather special. It was Lower Oxford Clay and contained 5 per cent seaweed that had been formed 150 million years ago. This burned and removed the need to add coal to the flame. It was a cost advantage.

Stewartby was a company village, started in 1926 by the London Brick Company. Nearly all the inhabitants worked for it, and in this respect it was similar to Bournville, built by and for Cadbury. The London Brick Company was acquired by the Stewart family in the 1920s and this accounts for the name Stewartby. Some people, and I am one of them, would call this showing off. Saltaire in West Yorkshire is the same. It was named after Sir Titus Salt, but he was a great man so perhaps we should forgive him. To be fair, Sir Halley Stewart was also a great man. The village was named after him following his death at the age of ninety-nine. The Stewarts paid fair wages and provided good staff facilities in a filthy working environment.

There is an amusing story about a town that was nearly named after a famous man. Rugeley in Staffordshire was the home of Dr William Palmer, known as *Palmer the Poisoner*, and scene of the numerous murders committed by him. The name Rugeley became so notorious that the inhabitants requested that its name be changed, and to this end sent a deputation to see the Home Secretary. He agreed, but only on condition that it be named after him. The Home Secretary was Lord Palmerston. It is a splendid story and very widely believed, but unfortunately it is not true.

The London Brick Company had its origins in Huntingdonshire, but it very shrewdly bought large areas of land in the Marston Vale area. The company wisely eschewed short-term profits and invested for the long term. This policy and the advantages provided by the Lower Oxford Clay paid off. Between 1900 and 1930 two thirds of the country's brickworks closed, but these prospered.

From 1939 the fortunes of the company fluctuated and a shortage of labour was sometimes a problem. After 1945 a number of Italian prisoners of war stayed in the area and were employed at Stewartby, and other Italians subsequently joined them. 783 Italians came in 1955 and immigrant workers also came from Poland, Ukraine and elsewhere.

Following a fiercely resisted takeover bid Hanson Trust acquired the company in 1984. The price paid was £247 million. In the next year 1,285 workers were made redundant, 407 of them from Stewartby. The same number were taken on during the subsequent three years. This pattern continued, but problems accumulated and production ceased in 2008. The final insurmountable difficulty was the failure to meet UK limits for sulphur dioxide emissions. Hanson spent a lot of money and tried hard to do so, but could not succeed. The four chimneys were due to be demolished on closure, but are now subject to a preservation order.

Most readers will not have these memories, but the view will be poignant for those that do. Even without the memories the others will, I hope, have a good feeling for what it was like. It is gone forever.

The Two Cardington Hangars

The two Cardington hangars are, not surprisingly, located in the small village of Cardington, which is on the eastern edge of Bedford. The hangars (which are often called sheds) are massive and very much a local landmark. Their size can be gauged by the fact that they can initially be seen very shortly after the first sighting of the Stewartby chimneys. It is necessary to look forward to the horizon on the right-hand side of the train. They can then be seen on and off until Bedford is nearly reached. The two sheds have a long and interesting history and have had many uses, but they will always be associated with the ill-fated R101 airship.

The Number 1 Shed is now more than 100 years old. It seems mighty to us now, so it must have seemed even mightier when it was built. It was constructed in 1915 by the private company Short Brothers, the purpose being to facilitate the construction of airships for the use of the Royal Navy. When built it was 700 feet long and 800 people worked there in 1917. The site was nationalised in 1919 and took the name 'The Royal Airship Works'.

The Number 2 Shed was originally located at RNAS Pulham, but it was dismantled and rebuilt in Cardington in 1928.

Big as it was, the Number 1 Shed had to be expanded to accommodate the building of the R101 airship. This was done between 1924 and 1926 and the size was increased to a length

The Cardington Hangars: birthplace of the R101.

of 812 feet, a width of 275 feet and a height of 179 feet. To put this into context, the floor area was 2.87 times the area of the football pitch at Wembley Stadium. Usain Bolt, travelling at his 100-metres world-record speed, would take 23.7 seconds to run the length of it.

The R101 was one of two rigid airships commissioned by the government to develop long distance airship travel within the British Empire. The other was the R100 built by a subsidiary company of Vickers-Armstrong. Barnes Wallis of bouncing bomb fame was the chief designer of that one. The R100 project was financed by the government and the R101 at Cardington was designed and built by the Air Ministry. It had a top speed of 70 mph, so it would have taken a long time to reach the far points of the empire.

Both airships were ready to be moved outside by late 1929. The R101 caused great interest and over several weeks a vast number of people went to Cardington to see it moored outside Number 1 Shed. The narrow surrounding roads were gridlocked. Following extensive trial flights and modifications the R101 departed for its maiden empire flight on 4 October 1930. The intended destination was Karachi in what was then British India.

Although the loss of life was much smaller, the tragedy that followed has similarities with the loss of the *Titanic*. Both perished on their maiden voyages. The R101 only got as far as Allone, west of Paris, when it came gently down and burst into flames on hitting the ground. Forty-eight of the fifty-four passengers died, and among those that perished was the Minister for Air, Lord Thomson. The bodies laid in state in Westminster Hall, and a

memorial service was held at St Paul's Cathedral. Then many of the dead were buried in a common grave in the cemetery of St Mary's church in Cardington. A monument was later erected and the scorched Royal Air Force Ensign that the R101 had flown on its tail is held at the church.

A subsequent enquiry came to the conclusion that a tear had probably developed in the forward cover, which had caused one or more of the forward gas bags to fail. This had led to the airship coming down. The cause of the fire was not established. Following the disaster the R100 was scrapped and the airship programme abandoned. It was never resumed.

Subsequent to this, the hangars have been put to a great variety of uses. First of all they became an RAF storage station, then from 1936 to 1937 barrage balloons were built. During the Second World War they were used to hold prisoners of war in transit. The two hangars ceased being part of the RAF Cardington site in the late 1940s.

From 1970 the Number 2 Shed was used by the Fire Research Station for large-scale fire tests. Then in 1972 this body merged with the Building Research Station to form the Building Research Establishment. Its work included constructing buildings then destructively testing them.

During the 1990s the Number 2 Shed was completely reclad by the Property Services Agency, and also in the 1990s a company called Airship Industries used the Number 1 Shed to try and revive the fortunes of the airship industry. Unfortunately the venture failed. In 2011 two Goodyear Blimps were refurbished in the Number 1 Shed prior to their use in a European tour promoting road safety.

The Number 1 Shed is currently used by Hybrid Air Vehicles Ltd, which does exactly what the name says. It designs and manufactures vehicles for transporting goods through the air. At the time of writing the company is close to producing a vessel that will carry over 50 tonnes of cargo, with a cargo bay volume in excess of 500 cubic metres. The company, which has its headquarters at Cardington, has high hopes for it. The Number 2 Shed is sometimes used as a film studio.

The R101 will forever be the first thing that comes to mind when the Cardington Hangars are seen, but that is by a long way not the whole story. They have a fascinating past. Let us hope that they have a great future too.

The Garden of Eden

As your train approaches Bedford you might like to spend a few moments reflecting that, according to the beliefs of the now extinct Panacea Society, you are entering the Garden of Eden. They did not mean this symbolically; they meant that Bedford and the surrounding area was the actual location of the biblical Garden of Eden as described in the Book of Genesis. The Panacea Society and the beliefs of its members are most definitely worth a chapter of this book.

The Panacea Society was a religious community formed in 1919 in Bedford by Mabel Bartrop. She was the widow of a clergyman and fifty-three years old at the time. In the 1920s and 1930s membership of the community peaked at more than seventy resident members living in and around Albany Road, Bedford. There were a further 2,000 members around the world. After a steady decline in numbers the last member died in 2012.

The garden of the Panacea Museum in Bedford.

Mabel's first inspiration was the writings of Joanna Southcott, which she discovered in 1914. Joanna was the sixth of seven prophets in a religious tradition known as the Visitation. This led to Mabel gathering a group of people in Bedford. In 1919 she came to believe that she was the eighth and final prophet. She chose to be known as Octavia because of the word's association with the number eight, as in octagon and octet. She is called Octavia in the remainder of this chapter. Octavia believed that she was Shiloh, another messiah come to earth before the return of Jesus. Her followers shared this belief.

After Octavia the most important member of the community was Emily Goodwin. She believed that she was in contact with the 'Divine Mother' and received messages from her. In 1923 Emily told the community that the Divine Mother had revealed the existence of a 'foursquare God'. This was father, mother, son (Jesus) and daughter (Shiloh – Octavia). Octavia and the community accepted this.

Octavia believed that she received daily messages from God and she relayed them to the community. It was one such message that told her that Bedford was the site of the Garden of Eden. She also passed on her own numerous ideas and rules for the right way of living. This was so that the members of the community could prepare themselves for God's perfected earth. It was difficult to know where God's messages stopped and Octavia's began. She believed that the British Empire and the monarchy were on God's side, and that communism, the Labour Party and the trade unions were evil forces opposed to God.

You have probably been astonished by what you have already read, but there is much more to come. To continue, in 1923 Octavia confided to some members of the community that Arthur, her late husband, had been Jesus, and that accordingly Jesus had lived on earth twice. Rather curiously, given this belief, she regarded herself as intellectually superior to her husband. It was known that she sometimes let him win when they were playing games together.

The community accepted men but the majority were women. Furthermore, a lot of them were middle aged or older. Many were single women or widows. They believed that women had a special role and the society was largely run by women for women.

In 1919 Octavia set about appointing twelve apostles, all women. This followed the action of Jesus as described in the Gospels, and on 1 January 1920 she followed Jesus' action in washing the feet of the chosen twelve. Rather curiously (or sinisterly you might think) she believed that each apostle should have been born under a different sign of the zodiac. Each of the twelve apostles was to gather in one twelfth of the final number of 144,000 who were saved. This number is mentioned in the Book of Revelation (Chapter 7 verse 4).

In 1923 the Divine Mother, through the medium of Emily Goodwin, proclaimed that Octavia had the power to heal. She did this by breathing on rolls of linen, which were then cut into small squares. These were sent to people who requested them. The linen squares had to be prayed over, then immersed in water. The water was then drunk, bathed in or applied to afflicted parts of the body. Steady improvements rather than sudden cures were promised. Faith was not a requirement and no charge was made. The linen squares were made freely available and over the years more than 130,000 were supplied around the world. The healing water was a panacea, which inspired the name Panacea Society.

To the extent that the public was and is aware of the Panacea Society, it is largely because of its campaign to have Joanna Southcott's box of sealed writings opened. It will be recalled that she was the sixth of the eight prophets in the religious tradition known as the Visitation (Octavia was the eighth).

In 1814 Joanna Southcott, then aged sixty-four, announced that she was pregnant and that the child she was carrying was the messiah. She displayed signs of pregnancy, and seventeen out of twenty-one doctors who examined her expressed the view that she was indeed pregnant. Elaborate preparations for the birth were made, including gifts of special clothes and a gilded cot. However, the due date passed without Joanna giving birth. She died shortly afterwards and an examination showed that she had not been pregnant.

Joanna Southcott left a sealed wooden box of prophecies, with instructions that the box was to be opened at a time of national crisis, and in the presence of all twenty-four bishops of the Church of England (there were only twenty-four at the time). The opening was to follow a period of three days during which the bishops studied her other prophecies and prayed. The prophecies would be of vast benefit to the nation, and hence to the world. Over the years the box was kept by a number of Southcott supporters and in 1957 it was given to the Panacea Society. It has been kept by them and the succeeding charitable trust ever since.

Over the years attempts were made to persuade the bishops to open the box, notably during the Crimean War. The cause was taken up by Octavia and her community during the First World War, a clear time of national crisis. Needless to say their attempts failed, but their crusade intensified and continued for more than seventy years. It never came remotely close to succeeding. Generations of bishops regarded it as palpable nonsense, and refused all the requests and pleading.

The Panacea Society repeatedly wrote to the bishops and organised petitions. They advertised in newspapers, starting in the 1920s and only finishing in the 1990s. Some readers may well remember the adverts. They advertised on the sides of buses and they ran poster campaigns. The following is the wording of one of the posters.

<div align="center">

CRIME
and
BANDITRY
DISTRESS
and
PERPLEXITY
will increase
until
THE BISHOPS
open
JOANNA SOUTHCOTT'S
BOX

</div>

Rather touchingly the Society made elaborate preparations to welcome the bishops. It purchased a property in Newnham Road, Bedford, which was adjacent to Albany Road where Octavia and many members lived. It was furnished to a high standard for the use of the bishops. One of the rooms had a table and twenty-four chairs. This was earmarked for the bishops to assemble, pray, discuss and then open the box. There were bedrooms, bathrooms and a kitchen. Octavia planned it all in meticulous detail, even down to purchasing twenty-four hot water bottles in case the bishops came in winter. The rooms were never used. The box still exists and it has never been opened. It seems unlikely that the bishops will ever have a change of heart, but if they do it is still available to them.

Octavia died in 1934 at the age of sixty-eight. This was a shock to the members who thought that she was immortal. For a time afterwards they anticipated her resurrection, but it did not happen. Membership actually increased for a time after her death. Emily Goodwin, she who was in touch with the Divine Mother, led the community until her death in 1943.

No form of priesthood or religious leadership developed. Instead the members met for worship in the chapel that had been built, and quietly shared their beliefs with friends. As well as advertising their wish that Joanna Southcott's box be opened, they advertised the availability of the healing water. Before her death Octavia had breathed on numerous rolls of linen, and the squares were still available. The membership inexorably declined and eventually the meetings and activities ceased. The last member died in 2012.

The Panacea Society was relatively wealthy and its funds were applied to the setting up of the Panacea Charitable Trust. Among other things this owns and runs the Panacea Museum. This is located in the house that was made available for the use of the bishops. It links to Octavia's house and there is a large garden in between. The whole area comprises the Panacea Museum. This is larger and more comprehensive than I expected and it is well worth a visit. You would see the rooms made available for the use of the bishops, the chapel, the clock tower that the members had built, and many other things. There are numerous exhibits and the history and beliefs of the Panacea Society are comprehensively explained.

The large garden is restful and beautifully maintained. Photographs show Society members enjoying tea parties in it and the museum has a tea shop. The photograph in this

chapter shows the garden looking towards the house and the clock tower. Gaze on it and, if you are a believer, reflect that you are gazing at the heart of the Garden of Even.

The Panacea Museum is at 9 Newnham Road, Bedford MK40 3NX. The website is www.panaceatrust.org and the telephone number is 01234 353178. The museum and gardens are open from 10.00 a.m. to 4.00 p.m. on Thursday, Friday and Saturday from February half-term to October half-term. The gardens only are also open from 10.00 a.m. to 4.00 p.m. on Monday to Wednesday from May to August. Admission is free.

Bedford and the River Great Ouse

Bedford is four miles beyond the Stewartby Brick Chimneys, and the line crosses the River Great Ouse shortly before it reaches Bedford station.

Bedford Bridge on the River Great Ouse.

The Great Ouse is 143 miles long and is the fourth longest river in Britain. It has more than one source near the village of Syresham in Northamptonshire, and it flows through Buckingham, Bedford, Huntingdon, Ely, then through Kings Lynn to enter the North Sea in the Wash. As the old saying has it: 'It all comes out in the Wash.'

Bedford makes the most of its river and the Embankment is lined with gardens for a considerable distance. They are beautifully designed and maintained. Long relaxing walks on both banks of the river are a delight, and a pleasure that I periodically take. The Bedford Rowing Club boathouse is close to Bedford Bridge and a variety of boats are frequently seen on the river. There are a number of regattas each year and the Bedford Regatta, measured by the number of crews competing, is the second biggest in Britain. Boats take paying passengers up and down the river and they are a pleasant diversion.

Bedford's most famous former inhabitants are John Bunyan and John Howard. Both have statues in the town. Bunyan's is on the corner of the High Street and St Peter's Street. Howard's is in St Paul's Square.

John Bunyan wrote nearly sixty books, but he is remembered chiefly for *The Pilgrim's Progress*, regarded as one of the greatest books in the English language. He was born in 1628 at Elstow, just outside Bedford, and he spent all of his life in or just outside the town. He died in 1688. Just before his sixteenth birthday he enlisted in the Parliamentary Army and served for three years during the Civil War. Following this he married and became very religious, firstly within the Church of England and then as a Nonconformist. He became an outstanding preacher and writer within the Bedford Meeting, a Nonconformist group based in Bedford.

After the restoration of the monarchy in 1660 the freedom of Nonconformists was curtailed, something that Bunyan was not willing to accept. He refused to give up preaching and as a consequence he spent twelve years in gaol. He was convicted of having 'devilishly and perniciously abstained from coming to church to hear divine service, and having held several unlawful meetings and conventicles, to the great disturbance and distraction of the good subjects of the kingdom'. If like me you are not familiar with the word conventicle, you might like to know that it is a secret or unauthorised assembly for worship. He subsequently spent a further short time in prison.

Bunyan started work on *The Pilgrim's Progress* while in gaol and it was published in 1678. As a boy I was told that he wrote the book on lavatory paper, but I do not now believe that this was the case. Part of his imprisonment was in a one-person gaol at Bedford Bridge. A plaque on the bridge reads:

<div align="center">

On the shallow East of the 3rd Pier
of the Bridge
stood the "Stone-House"
wherein BUNYAN imprisoned
1675–76
wrote the first part of the
Pilgrim's Progress
"As I slept I dreamed a dream"

</div>

The book is universally known as *The Pilgrim's Progress* but its full title is *The Pilgrim's Progress from This World to That Which is to Come; Delivered under the Substitute of a Dream*. The book has been translated into 200 languages and has never been out of print. It is a Christian allegory, which describes Christian's journey from his hometown, the City of

Destruction (this world) to the Celestial City (Heaven). Along the way he encounters and overcomes such difficulties as the Slough of Despond. His journey is hampered by a burden that he carries, but he manages to cast it off. Christians will recognise the symbolism of these descriptions and of many others in the book.

It is believed that many of the scenes in the book are inspired by places around Bedford familiar to Bunyan. One example is the Slough of Despond, which is believed to be influenced by the clay deposits around Stewartby. This is the location of the brick chimneys described in a previous chapter of this book.

The inscription on John Howard's statue gives just his name and dates, which were 1726–1790. This is followed by 1890 to show that it was erected to mark the centenary of his death. He is remembered as a philanthropist, but his main claim to fame is as a prison reformer. For much of his life his home was at Cardington, a village just outside Bedford and now notable for the two enormous hangars described in an earlier chapter of this book. He was elected a Fellow of the Royal Society in 1756, and an example of his philanthropy is that in 1782 he was paying for the education of twenty-three children in Cardington.

In 1773 Howard was appointed High Sheriff of Bedfordshire, and in this capacity he inspected the county prison. He was shocked at what he saw and he devoted the rest of his life to prison reform. He inspected numerous prisons and took his concerns to Parliament. He gave evidence on prison conditions to a House of Commons Select Committee. Afterwards, in a rare honour, he was called to the bar of the House of Commons and thanked for his humanity and zeal.

He continued his prison visits, including some in Europe, and in 1777 he published *The State of Prisons*. In 1784 he calculated that in making his prison visits he had travelled a total of 42,000 miles. Indefatigable campaigner that he was, this must surely be an exaggeration. This distance is nearly twice the circumference of the earth, and in the pre-railway age he would have had to have averaged more than ten miles each and every day for the previous ten years.

John Howard died after contracting typhus while inspecting Russian military prisons in the Ukraine. He was the first civilian to be honoured with a statue in St Paul's Cathedral. Eighty years after his death the Howard Association was formed and named after him. In 1921 it was merged with the Penal Reform League to become the Howard League of Penal Reform.

Bedford Bridge and the area just north of it is a focal point of the town. The inscription concerning John Bunyan's imprisonment is on the north part of the bridge, and St Paul's Square containing John Howard's statue is not far away. The embankment and gardens are close by. Not least of the area's attractions is the Swan Hotel, and I speak from experience in recommending it for dinner or afternoon tea. The original hotel dates from the eighteenth century, but it has been extensively refurbished and transformed. It runs for a considerable way along the banks of the Great Ouse and the views are marvellous.

There is a striking war memorial in front of the hotel. It is for the Boer War (1899–1902) and it is dedicated to the 242 men of Bedfordshire Regiments and Bedfordshire men of other regiments who lost their lives. My first reaction was that it is an outstanding memorial, and my second was surprise that the number of names was so high. My third reaction was dismay that the names are grouped separately into Officers, Non-Commissioned Officers and Men. Furthermore, the Officers and Non-Commissioned Officers are listed in descending order of rank, rather than in alphabetical order. I think that death levels all ranks, or at least should do.

Some people think that the Boer War brought discredit to Britain, and that the unfortunate 242 did not die in a just cause. Lloyd George led the opposition to it. He said that it was all about diamonds, and that it was rather like the British Empire fighting Caernarvonshire. He added that Caernarvonshire appeared to be winning.

Along the embankment is the memorial for the fallen of the First World War, the Second World War and the Korean War. This does not list names. I was moved by one of the wreaths lying at the base. The inscription read 'To Grandad and Great Grandad. Thank You for My Freedom. In Remembrance'. We have a lot to be grateful for.

Bedford is the county town of Bedfordshire. It was founded at a ford of the river and its origins date back to Saxon times. Offa of Mercia, a name familiar because of Offa's Dyke, was buried there in AD 796. It became a borough in 1166.

Modern Bedford is particularly ethnically diverse. It is notable that almost 30 per cent of the population is at least partly of Italian descent. This is because some Italian prisoners of war stayed after the end of the Second World War, and because in the post-war years Italians were recruited to work in the local brickworks. This heritage is reflected in the plethora of Italian restaurants, bars and other businesses. From 1954 to 2008 Bedford had its own Italian vice-consulate.

There has also been significant immigration from South Asia, particularly the Punjab, and from Eastern Europe. The diversity of immigrants has resulted in a variety of places of worship. They include the UK's largest Sikh temple outside of London.

You will probably pass through Bedford at around 90 mph, but if you get the chance it is worth a visit.

Bromham Lake Nature Reserve

The nature reserve is on the left side of the train and four miles beyond Bedford. It is very shortly before a modern road bridge and is irregularly shaped, but part of its boundary runs immediately next to the line and no more than ten yards from the track. The site consists of twenty-five acres and it is owned and managed by Bedford Borough Council.

The reserve was established in the 1980s from former mineral workings, and it was declared a local nature reserve in 1991. As its name implies the reserve includes a lake, which cannot be seen from the train. This was formed when the site was worked for sand, limestone and gravel between 1969 and 1975. When this was taking place the remains of what is described as an Iron Age house was found. I confess to wondering if our Iron Age ancestors lived in houses, but the remains of a dwelling were discovered.

The site was restored with woodland and wildflower planting, then left to develop naturally. Rather appropriately the grassland contains a colony of bee orchids, which are Bedfordshire's county flower. The whole area is rich in flowers, insects and butterflies.

The lake, which is important for birdlife, contains rafts for their benefit. Frequently seen are, among others, common tern, coot and Canada goose. Occasional visitors include kingfishers and herons.

My visit was very relaxing, partly because of the beauty and interest of the reserve, and partly because I did not see another person or any litter at all. What I did see was a

The tranquillity of Bromham Lake Nature Reserve.

vast quantity of blackberries. They were ready for picking, and if you enjoy cooking with blackberries an early autumn visit will be very rewarding.

The reserve is open 365 days a year and entrance is free. Volunteers are very welcome.

Sharnbrook Railway Viaducts

The two side-by-side viaducts cross the river Great Ouse seven miles beyond Bedford and three miles beyond the Bromham Lake Nature Reserve. Normally, on the train at least, only a person in the driver's cab sees a viaduct properly, but as there are two side-by-side you will have a close view of the one on the right. They are set in pretty countryside and cross a pretty river. The River Great Ouse is the fourth longest in Britain and rises near Syresham in Northamptonshire.

Both of the structures were built by the engineer, John Underwood. The so-called 'New Viaduct' was constructed in 1879 and the so-called 'Old Viaduct' was built in 1881. Extensive repairs to both of them were carried out by the London, Midland and

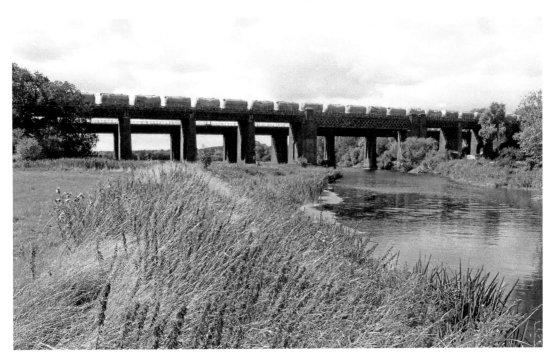

The two viaducts over the River Great Ouse.

Scottish Railway in 1933–34. The New Viaduct was needed to cope with the increasing railway traffic. The reason that the Old Viaduct was built second is that it replaced an earlier one built in 1853–57.

The original viaduct was built under the supervision of the engineer, Charles Liddell. It was a substantial brick structure of ten semicircular arches. It began to fail in the 1870s due to instability in one of its river piers. The reconstruction was on its original footprint. It has brick piers and a deck of wrought iron girders. It crosses the river on three sixty-foot spans. The New Viaduct is similar but crosses the river on a single 115-foot span. The trains traverse the water at a height of 36 feet.

The viaducts can be approached by a bridleway starting close to the Sharnbrook Mill Theatre. This is an old brick building, the end of which can be glimpsed on the left side by looking sharply backwards as the train crosses the viaduct. The Domesday Book records a mill on the site, jointly owned by Countess Judith, niece of William I and Hugh de Beauchamp. The oldest part of the building still standing dates from 1703. The Mill House, which had been attached to the Mill, was rebuilt in stone around 1817. A turbine replaced two wheels in 1889 and this was in use until 1969. Water power was augmented, at first by steam in the mid-to-late-nineteenth century, subsequently by diesel and finally, in 1962, by electricity. The Mill House is now a hotel and restaurant overlooking the River Great Ouse.

The Mill has been converted into a 200-seat theatre. A highly regarded amateur company puts on five or six productions a year. The theatre was established in the village in 1943 in order to entertain troops stationed in the locality. It subsequently moved to Rushden, then to the Mill just over twenty-five years ago. Its website tells us that performances sell out quickly and that early booking is recommended.

More Nature Reserves

It is characteristic of the human condition that activities of a certain type tend to congregate in proximity together. For example numerous technology companies operate in the M4 corridor, and the country's rhubarb growing business is concentrated in the so-called rhubarb triangle between Wakefield, Morley and Rothwell. If it is nature reserves that you are after, you could do a lot worse than follow the railway line from Bedford to Wellingborough.

The previous but one chapter describes the Bromham Lake Nature Reserve, which is four miles beyond Bedford. We now move on to the Sharnbrook and Wymington Meadow Nature Reserve, which is managed by the Wildlife Trust for Bedfordshire, Cambridgeshire and Northamptonshire. Despite the name it is not at the villages of Sharnbrook or Wymington, something that I found to my cost when looking for it. It is encountered three miles beyond the Sharnbrook Railway Viaducts.

The reserve is long and thin, the explanation being that it is built over a railway tunnel that is slightly more than a mile in length. This was built for the line in 1854. It is now used for goods and the rumbling of trains can be heard through the air vents. The passenger line on which you will travel runs alongside and does not pass through a tunnel. To see the reserve you will need to look to the right and slightly upwards.

Ditchford Lock.

The Trust says that the grassland has developed on the limestone soils excavated during the construction of the tunnel, and that there are still remnants of richer flora from days gone by. There are delicate white flowers of dropwort and yellows of dyer's greenweed. Also notable is the nationally rare grey mouse-ear, which has a foothold. There are many small mammals, butterflies and a variety of birds. Birds of prey are often seen, including kestrels and buzzards.

Wellingborough station is on the eastern extremity of Wellingborough, so the town is on the left side of the train and countryside is on the right. The line crosses the River Nene shortly before the station is reached. There are numerous flooded areas, both upstream and downstream. They are mainly based on flooded gravel pits.

On the right side of the train are, progressively, three nature reserves, all of them administered by the Wildlife Trust for Bedfordshire, Cambridgeshire and Northamptonshire. The nearest to the line is the Ditchford Lakes and Meadows Nature Reserve. The other two are the Wilson's Pits Nature Reserve and the Higham Ferrers Nature Reserve. The line of the river can be followed between the flooded pits, and a feature is the Ditchford lock. This chapter's picture shows this.

The three reserves are part of the upper Nene Valley flood plain, and are important for breeding and winter birds. The water is surrounded by grassland and mature scrub, mainly willow. Grass snakes are frequently seen and otters often visit. Damselflies and hairy dragonflies are there too. To introduce an inappropriate comment, I have never seen a bald dragonfly, but the hairy ones are certainly there.

The bridge over the river blocks the view, but the first reserve can be seen on the right side of the train immediately before and immediately after it. I needed to prove this to myself so I undertook a return train trip from Wellingborough to Bedford. It takes just under fifteen minutes each way. As we approached the bridge a voice was heard to say 'Tickets from Wellingborough please'. I fumbled for my ticket and railcard and as a consequence did not see what I was looking for. At the key moment coming back I heard 'Tickets from Bedford please' and exactly the same thing happened. I take my responsibilities to you the reader seriously, so I made the return journey again. This time I saw it.

St Katherine's Church, Irchester

Numerous very fine churches can be seen on the route from St Pancras to Sheffield. So far only the cathedral at St Albans has been given a chapter in this book, and this is very far from typical of the many superb village churches close to the line, so St Katherine's church in the village of Irchester is now featured. It is a splendid building and can represent others that might well have been included. A significant part of the spire can be seen on the left side of the train shortly before it reaches Wellingborough.

St Katherine's is Church of England and is the parish church of the village of Irchester. The story, some would say legend, of St Katherine (sometimes spelled Catherine) of Alexandria is that she was a Christian saint and virgin martyred in the fourth century at the hands of the pagan emperor Maxentius. She was a scholarly girl and had come to believe in Christianity around the age of fourteen; she subsequently converted hundreds of people to her religion. 1,100 years later Joan of Arc identified her as one of the saints who appeared to her and counselled her. The Catherine Wheel firework is named after her. The spire that

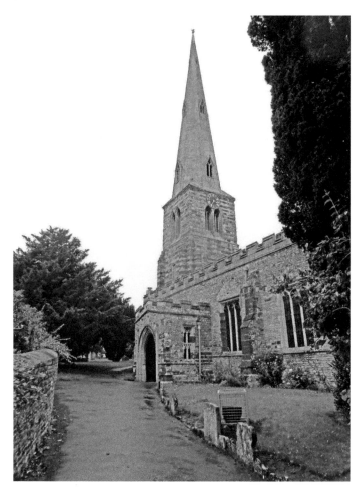

St Katherine's Church.

you can see rises to a height of 160 feet. It is topped with a weathervane pierced in the form of a Catherine Wheel.

The church, which is a listed building, was built in the twelfth century, but an earlier church on the site is mentioned in the Domesday Book. At the time of compilation the settlement was called Irencestre. Some of the church's contents are of great antiquity. One notable feature is a bread oven used to bake altar bread, which dates from the thirteenth century. So it is certainly more than 700 years old and possibly more than 800 years old. The font is also from the thirteenth century.

Some of the oak pews date back to the fifteenth century, as do panels in the Chancel Screen. The medieval windows date back to 1450 and the pulpit is Jacobean. There are eight bells that are rung regularly.

Although it has a lot of history, it would be a mistake to overlook the fact that St Katherine's is still thriving and has a role to play in the twenty-first century. The church website lists a number of things with which it is involved. Not surprisingly there is the choir, and other activities include drama, bell-ringing and morris dancing.

I was in a reflective mood while looking at the church and a couple of thoughts occurred to me. The first, a sad one, was triggered by the fact that the building was locked. In my

youth this probably would not have been the case – most churches were kept open most of the time. I recall more than once being out with my parents or grandparents and going into a church, either to have a look or have a rest. Some passers-by might do so for devotional reasons. I do not blame the church authorities, but it is a shame that this is not now possible. My second contemplation was to marvel at the commitment of the people who built this and other churches. The 2011 census indicates that the population of Irchester was 4,745 and the 1801 census put it at just 523. Heaven only knows (an apt phrase) how many people lived there when the church was built. It must have taken a relatively large part of their wealth and work. The spire was erected not long after King John sealed Magna Carta at Runnymede. The stones were hauled to the site, cut and shaped, hauled into the air and placed 160 feet above the ground, and it was all done without electricity, steam power, lifts or any of the equipment that we use today. They took their religion seriously then.

Wicksteed Park

When I agreed to write this book I very much hoped that Wicksteed Park could be seen from the window of the train. It can, though you will have to look carefully. The park is in

The Wicksteed Park narrow gauge train.

Kettering, before the station and on the right side of the train. Your view will be of a fishing lake and you look down on it, and you have to look through or round a row of trees, so it is harder to see in the summer – the clearest view is looking slightly backwards just after the train has passed the lake.

The reason for my hope was that I have spent many happy days there. When I was a relatively young child it was the destination for several Sunday school outings. They were always on Whit Monday and the weather was always good (it may be a false memory but that is the way that I remember it). Whit Monday was the traditional day for Sunday school outings and there were invariably rows of coaches at the park. At the time there were more Sunday schools and more Sunday school outings. As an adult I have enjoyed taking my children and later my grandchildren. I have many fond memories and I enjoyed my visit while writing this book.

Wicksteed Park covers 147 acres of which twenty-five are the boating lake. It opened in 1921 and is the second oldest theme park in the UK. The distinction of being the oldest goes to Blackgang Chine on the Isle of Wight. The Kettering Park was founded by Charles Wicksteed, a remarkable engineer and a remarkable man – we owe him quite a debt.

The founder was one of nine children and the son of a well-known Unitarian minister of the same name. He was making ploughing tackle at the age of nineteen and at twenty-one he set up Charles Wicksteed and Co Ltd, based in Kettering. The Victorians spawned quite a number of brilliant engineers who started at a very early age. Wicksteed had something in common with Robert Stephenson who was making steam engines in Newcastle at the age of twenty-one.

In the early days Wicksteed's company made bicycles, but it moved on to a range of other products. It was his inventiveness that made several of them possible. Among other things it produced the first hydraulic hacksaw, the original gearbox, sawing machinery, wooden toys and power drills. During the First World War it made munitions and after the war it made children's swings. This venture became Wicksteed Playscapes and it is still operating.

Wicksteed wanted to give something back and in 1913 he purchased the land which is now the park. His original intention was to build a model village, but he abandoned this due to the development of council housing after the war. Instead he decided to set up the park. He loved children, which was a factor in the decision. Wicksteed Park is owned by a company that is in turn owned by the Wicksteed Trust, which is a registered charity. The Trust was set up by Charles Wicksteed in 1916. He died in 1931 at the age of eighty-three and we have much to thank him for.

There is a modest car park charge, but otherwise entry to the park is free. You really can walk through the gate without paying, something that cannot be said about Alton Towers, Legoland and most (perhaps all) of Wicksteed's rival attractions. Enjoyment of the large playground area near the entrance is free, and you can bring a picnic, enjoy the scenery and have a day there for no charge at all. Tickets for the attractions can be bought individually or an all-day unlimited-ride wristband can be purchased.

The attractions can be divided into four themed areas:

1. The free playground.
2. The fairground – this contains rides for children up to the age of thirteen or fourteen and includes the Fun Palace Arcade.
3. Lakeside – this predominately features rides themed around water, such as the rowing boats and the water chute.
4. The arena – this includes many of the park's longer rides. They include the Ladybird Coaster, the Revolving Paratrooper, the Roller Coaster and the Log Flume.

All those years ago when I visited with the Sunday school my two favourites were the water chute and the narrow gauge railway. They are both still there and both have been improved. The waterchute was designed by Charles Wicksteed and was opened in 1926. It is the oldest of its type in the country. There was always a long queue and a few seconds of glorious anticipation as you plunged towards the water. You were guaranteed to get wet, which for some reason appeals to most children and many adults too. It certainly used to appeal to me.

The narrow gauge railway was opened in 1931, just before the death of Charles Wicksteed. Since then more than 15 million people have ridden on it. Support is given by the Friends of the Wicksteed Park Railway. The gauge is 2 feet (610 mm), which compares with the standard gauge of 4 feet 8½ inches used in Britain and most of the world.

The line goes around the park, passing through tunnels and across the strip between the boating lake and the fishing lake that can be seen from the train. This chapter's picture shows the train approaching its departure station.

I have many happy memories of visits to Wicksteed Park, including one while writing this book, but you might like to hear about an unhappy one. It is amusing to me now and it was amusing to my family at the time, but not to me. When my daughter was seven and my son four my wife and I took them there for the day. It was the first day of the Easter holidays at my daughter's school – Easter was early that year and it was very cold with light rainfall. We were first through the gates when the park opened. I immediately took my daughter on a ride where we sat together on a pretend aeroplane. This was at the end of an arm and the plane circulated at speed around 10 feet off the ground, and it bumped up and down as it did so. You normally get around three minutes, but as we were the only customers around the attendant retired to the comfort of a warm hut and left us to enjoy ourselves. We went round and round for nearly a quarter of an hour. After a few minutes I began to suffer from severe motion sickness. I kept shouting that I wanted to be let down, but all he did was wave back under the impression that we were having a good time and that I was showing my appreciation. Happy days!

The Triangular Lodge

The Triangular Lodge has a pleasing appearance and is constructed of alternating bands of dark and light limestone. It is one mile from the village of Rushton and three miles beyond Kettering. It can clearly be seen from an embankment and it is on the left side of the train. It is necessary to look over a field, over a country road that runs parallel with the track and over a long wall. The Lodge is close to the wall. The vantage point is where the train passes some wind turbines close to the track.

The Triangular Lodge was designed and constructed by Sir Thomas Tresham between 1593 and 1597, so it is well over 400 years old. Tresham was a devout Roman Catholic who was imprisoned for a total of fifteen years because of his refusal to renounce his Catholic faith and his activities in support of it. The Lodge is a symbol of his faith and in particular of his Catholic faith. The word 'symbol' is carefully chosen because everything about the Lodge is symbolic and based on the number three – because of the Trinity: God the Father, God the Son and God the Holy Spirit. Some people, myself included, say Holy Ghost rather than Holy Spirit.

The upper part
of the Triangular
Lodge.

The Lodge is triangular, which of course means that it contains three outside walls. Each wall is thirty-three feet long, so the building is that of an equilateral triangle. Each wall has three triangular windows and is surmounted by three gargoyles. There is a triangular chimney and the Lodge has three floors upon a basement. There are three Latin texts on each façade, and they all contain thirty-three letters:

- *Aperiatur terra & germinet salvatorem* – Let the earth open and bring forth salvation (Isaiah 45.8)
- *Quis seperabit nos a charitate christi?* – Who shall separate us from the love of Christ? (Romans 8:35)
- *Consideravi opera tua, domine, et expavi* – I have contemplated thy works, O Lord, and was afraid (a paraphrase of Habakkuk 3:2)

The Book of Habakkuk is the eighth book of the twelve Minor Prophets in the Hebrew bible.

The entrance to the Lodge is in the south-east façade and Tresham's coat of arms is above the door. Underneath the coat of arms is the Latin inscription *Tres testimonium dant*, which translates as 'The number three bears witness.' Tres was the pet name his wife used for him.

The principal room on each floor is hexagonal, which means that the three corner spaces are triangular. Above the three Latin quotations are three steep gables, each surmounted by a three-sided obelisk. The inscriptions on the three gables combine to read *Respicite non mihi laboravi*, which translates as 'Behold I have not laboured for myself alone.' The basement windows are small trefoils with a triangular pane at their centre. As you may or may not know, a trefoil is any of a genus of leguminous plant having leaves divided into three leaflets.

There are more connections with the number three but we will stop there – some of the claimed connections are debatable and to me seem somewhat speculative. Departing from the number three there are many symbolic carvings. An example is a *Pelican in her Piety*, a symbol of Christ and the Eucharist.

Sir Thomas Tresham lived at nearby Rushton Hall and the Triangular Lodge was built in the grounds of the estate. After his death in 1605, ownership of the hall and the estate passed to his son and then to other family members. Ownership moved to other families and part of the estate was eventually sold. Since 1984 the Lodge has been in the care of English Heritage. It is open to the public, usually from late March to late October. It is recommended that the precise dates and times be checked before a visit is made. The admission charge for an adult is currently £3.50.

Rushton Hall was the ancestral home of the Tresham family and was bought by William Tresham in 1438. He was Attorney General to Henry V and his many other offices included Speaker of the House of Commons. William was murdered in 1450 by a group of men with whom he was engaged in a property dispute. His son Thomas (not the Thomas who built the Triangular Lodge) was injured in the attack, but he recovered and inherited the hall and the estate.

This Thomas also had a distinguished career and held a number of offices, and like his father he was Speaker of the House of Commons. The times were turbulent and he was active in wars and battles during the Wars of the Roses. At times he managed to please and displease both sides. When Henry VI regained the throne Thomas was imprisoned in the Tower of London from 1468 to 1470. After the Battle of Barnet he was executed in 1472. His estates were confiscated but they were restored by Henry VII to his son John in 1485.

The later Sir Thomas Tresham (the man who built the Triangular Lodge) was born in 1543, which was nine years after Henry VIII broke with the Catholic Church and founded the Protestant Church of England. He lived through very troubled times during which Protestants persecuted Catholics and Catholics persecuted Protestants. My Catholic friends would probably say that much of the persecution was directed against the Catholics. This Sir Thomas, at the age of fifteen, inherited the hall and the estate from his grandfather. Like his ancestors he held a number of high positions, including Sheriff for Northamptonshire, and he was knighted in 1575. He was a convinced and devout Roman Catholic and believed that the state should have no jurisdiction in matters of conscience. This led to several years of imprisonment, totalling fifteen years in all. His last spell of imprisonment was on the charge of harbouring Catholic priests.

Family drama and tragedy did not end with the death of Sir Thomas on 11 September 1605. Francis, his eldest son, inherited the title and the estate, together with the considerable debt that accompanied it. He was implicated in the Gunpowder Plot to blow up Parliament on 5 November 1605 and faced certain execution when he died of natural causes on

23 December 1605. After his death he was decapitated and his head was put on public display.

Rushton Hall is a very interesting building and contains many admired features, the Great Hall being particularly noteworthy. Like many Catholic-owned houses, it contained a priest hole where visiting priests could hide if it was necessary to do so. Tunnels ran from it to allow the priests to escape, and one of them went to the Triangular Lodge. The tunnels collapsed many years ago.

Rushton Hall was occupied by the military in the Second World War. It became a Grade I listed building in 1951, and it was an RNIB school for blind children from 1957 to 2002. It is now a four-star hotel and spa and is well worth a visit.

All Saints Church, Braybrooke

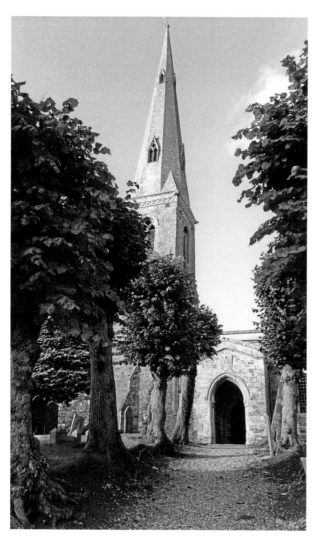

A fine view of All Saints church, Braybrooke.

This Church of England place of worship is eight miles beyond the Triangular Lodge and four miles before the town of Market Harborough. It is located at a crossroads in the small village of Braybrooke, and like many old rural churches it has a pleasing appearance. All Saints is on the left side of the train and around a quarter of a mile from the track. The elongated spire is prominent and the church can easily be seen. It is a Grade II listed building.

All Saints has a nave with four bay aisles, but the eastern bays on either side were originally transept arches. They date from the thirteenth century and the chancel is believed to date from around 1300. There is a chapel that contains a wooden effigy of Sir Thomas de Latymer, who, in the early fourteenth century, was granted a licence to strengthen his nearby manor house.

There is a two-storey perpendicular tower in ironstone ashlar, with an octagonal ashlar spire. The remainder of the church is of large, rough ashlar blocks, except for the south chapel, which is in very fine grey ashlar. (I had to look up the word ashlar and found that my dictionary describes it as a square block of hewn stone for use in building.) A particularly interesting feature of the interior is the font, a square twelfth-century sandstone bowl with a circular and lead-lined basin. It stands on a later octagonal shaft and base. After a period of neglect, sympathetic and extensive restoration work was carried out in the late nineteenth and early twentieth centuries.

I found it humbling to think that I was looking at something both beautiful and symbolic built more than 600 years ago, and that parts of the church are older still. Despite our country's burgeoning population, Braybrooke is still a small village and I reflected on the scale of labour and wealth that was invested in the church. Some numbers are instructive: the Domesday Book put the population of Braybrooke at twenty-one and in 1377 163 people over fourteen years of age paid poll tax. In 1801 the parish population was 378.

All Saints does not have a resident priest and is instead served by the vicar of nearby Desborough who looks after more than one parish. This is increasingly common in the Church of England, and in other denominations too. The church has close links with the nearby Baptist Church, which has a low membership. Joint meetings are frequently held.

The River Jordan flows through Braybrooke, though some might class it as a large stream. It is an appropriate biblical name and in days gone by the Baptists conducted adult baptisms in it.

Foxton Locks and the Leicester Line of the Grand Union Canal

Midway between Market Harborough and Leicester the railway runs close to the Leicester line of the Grand Union Canal. Foxton Locks, located four miles from Market Harborough, unfortunately cannot be seen from the train. They are one of the most fascinating sites on Britain's canal system and, if an opportunity arises, they are well worth a visit.

Work on the Leicestershire and Northamptonshire Union Canal commenced in 1793, which was the high point of canal mania. In the years 1793/94 there were thirty-eight Acts of Parliament for canal building, and in 1793 work was in progress on sixty-two different canals. They became the waterways that fed the Industrial Revolution.

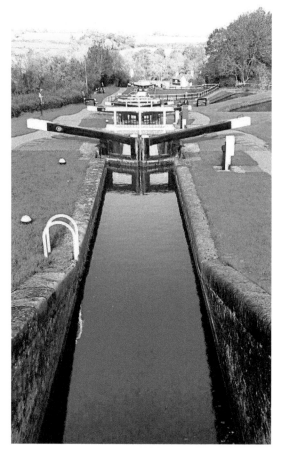

Foxton Locks from the top down.

The Leicestershire and Northamptonshire Union Canal was intended to connect with Northampton and the River Nene. However due to financial difficulties and problems with the construction of a tunnel its backers were forced to stop at Debdale, just north of Foxton. Financial difficulties were common during the construction of canals and later during the construction of railways. The canal was later extended with what is now the Harborough Arm, built on a revised route in 1809.

In 1810 a new company, now referred to as the 'Old Grand Union', was formed to build the link from Foxton on the Leicestershire and Northamptonshire Union Canal to Norton on the Grand Junction Canal. It was decided to construct the necessary locks with a 7ft gauge rather than a 14ft gauge. This decision was to have economic consequences. The Grand Junction Canal from London northwards (now the main part of the Grand Union Canal) was built with 14-foot gauge locks. An early and challenging task in 1810 was to ascend the canal 75 feet at Foxton.

Most British canals and the areas that surround them are visually attractive for most of their route, and are loved by walkers, cyclists and anglers, as well as the users of boats. Foxton Locks and the surrounding area is no exception and is exceptionally pretty. In this respect my opinion is supported by guidebooks and leaflets. There are two public houses at the foot of the flight of ten locks, and the lock-keeper's cottage at the top has been

made into a café. The public houses serve food and one of them has a large conservatory overlooking the canal. Surveying the scene and watching the boats and people go by can be a pleasant experience. Of course, today the boats are exclusively for pleasure, not for trade as in previous years.

The engineers who started to extend the canal in 1810 faced a formidable obstacle. Rather than following the contours and inserting a number of single locks they opted to go straight up the hill. The ten locks raise the boats a total of 75 feet, an average of 7½ feet per lock. Given a clear run it takes an average of forty-five minutes to pass through all the locks.

The ten locks, which were designed by Benjamin Bevan, are a staircase flight, with side pounds (often described as ponds) set alongside each one. They are in two sets of five, with a small passing pound between the two sets, enabling the boats to travel up and down simultaneously. The pounds save both time and water. The top gates of each lock are also the bottom gates of the next. Water passes from one lock into the side pond and then back into the next lock to equalise the levels. It is the longest set of staircase locks in Britain's canal system.

The Foxton design differs from the one usually used in a flight of locks. In most flights one lock, the next lock and the pound between are all at the same level. At Foxton the pounds are located at the sides of the locks. It is called a staircase because the locks are like steps, with the dividing gates on the edge of each step. Paddles (or sluices) are raised to let water from one lock into the side pound and back into the next lock to equalise the levels. The gates can then be opened to allow the boat through.

The locks are only minimally dug into the hill. This is because it would have been a heavy (and therefore expensive) job. Mechanical aids were not available at the time and all the digging and transporting of earth was done with shovels and barrows. Instead the locks were built almost on top of the ground, with earth then being heaped up around them. This increased their visibility and contributed to the spectacle that we can still see today.

Over the years the decision to build the locks at Foxton and Watford Gap with a seven-foot gauge rather than a fourteen-foot gauge limited the trade that passed through them. Watford Gap is in the Midlands, not at the familiar town in Hertfordshire. A wide boat could carry fifty tons of cargo, whereas a boat using a seven-foot gauge lock could only carry twenty-five tons. The crew and the horse would be the same in each case. In 1898 it was decided to install Inclined Plane Boat Lifts at Foxton and Watford. This would enable wider boats to use the canal, and it would reduce the problems sometimes caused by a shortage of water. Wide boats using the lift would bypass the bottleneck of the narrow locks.

The Foxton Inclined Plane Boat Lift was completed in 1900. Although it is not strictly correct to do so it will in this chapter be called the lift. The principles of its operation may be familiar to you if you have ever used a so-called cliff railway. There are several around the country, the famous one at Lynmouth in Devon being a good example.

The lift consisted of a pair of counterbalanced water tanks running on rails on a 1:4 slope. It had the capability of passing two narrowboats up and two down simultaneously. Each tank weighed 240 tons and the boats were in water the whole time. The lift was steam powered and a boiler house was constructed part of the way up the hill. The water tanks were mounted on bogies which were hauled up the rails by cables. The men who built the lift were mainly travelling navvies who lived in nearby huts. Sadly one of them suffered a fatal accident during the construction of the lift.

The lift was a technical triumph but it was not the commercial success that had been anticipated. For this reason it was only in use for ten years and its operation was

discontinued in 1910. Insufficient extra traffic was generated, partly because it was not economic to run it at night. After 1900 the locks were not used and were not maintained, but in 1908 the decision was made to restore them to working order. This was done between 1909 and 1910 and for a short time both the lift and the locks were in use. Then the lift was closed and it was locks only – a shame, but perhaps inevitable. The lift joined the long list of innovations that were very impressive but did not make money; the Concorde aeroplane is a spectacular example.

The heyday of the canals ended with the coming of the railways in the 1840s. The canals carried on, became more efficient and cut their rates to try and be competitive, but it was a hard struggle. The economics favoured the railways. In the twentieth century, and particularly after the Second World War, motor lorries and vans provided the killer blow to the carrying of freight by water. By the 1950s the Leicester Line had no regular trade and it became virtually derelict. The British Waterways fleet of commercial boats was disbanded after the big freeze of 1962/63.

The good news is that pleasure boats have rescued many of the canals, including the Leicester Line and the Foxton locks. They gained a foothold in the 1960s and have become more and more common ever since. There are now more pleasure boats using the Foxton locks than there were commercial boats when commercial use was at its peak.

Considerable sums of money have been spent restoring the canals, the locks, the towpaths and other facilities. Some of this has been done by volunteers and we have reason to be very grateful to them. Writing as a person who many years ago had holidays on the canals and who over the years has enjoyed walking the towpaths, I am happy to confirm that this has had great benefits. Numerous people, including my family and myself, have gained much pleasure as a result.

Foxton locks are a well-signposted visitor attraction and worth a visit. The address is Gumley Road, Foxton, LE16 7RA. As well as the locks it is possible to see the remains of the lift and to visit the Boiler House. This has been preserved as a museum and contains many artefacts and information about the lift and the locks. It is owned and run by Foxton Inclined Plane Trust, which is an independent charity. It is open from 10 a.m. to 5 p.m. in the summer, and 11 a.m. to 4 p.m. at the weekends and on selected weekdays in the winter. The entry charge is £4.00 for adults and £1.00 for accompanied children. The telephone number is 0116 279 1657 and the website is www.fipt.org.uk.

King Power Stadium:
Home of Leicester City Football Club

The subject of this and the next two chapters can be seen from almost the same place on the line. Lovers of the game played with a round ball will be pleased that their sport is mentioned first. It is necessary to look out of the left side of the train just under a mile before it reaches Leicester Station. The football stadium is close to the track.

There is something to be said for football clubs playing at locations they have used for many decades, even if there are apparently strong financial reasons for a move. It feels right that Manchester United are at Old Trafford and Newcastle United are at St James' Park – one senses that the ghosts of Duncan Edwards and Jackie Milburn look down with approval.

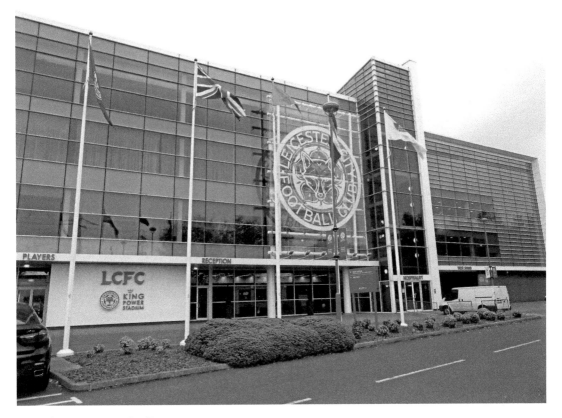

The King Power Stadium.

Still, it is just nostalgia and we must move with the times. However, Leicester City still play in Filbert Way, having been very close to the site (formerly at Filbert Street) since 1891.

The present stadium was opened in August 2002, just in time for the start of the 2002/03 season. It was originally called Walkers Stadium, being named after the company that makes Walkers Crisps, and Gary Lineker, the TV pundit and former Leicester player, cut a ribbon to mark the occasion. The present name dates from 2013 when Leicester City's Thai owners bought the ground through their company, King Power Holdings Co Ltd.

The ground's capacity is 32,500, all seated of course, and the pitch benefits from under-soil heating. There are two large video screens at opposite corners of the stadium. An interesting feature is a large perspex strip, which is located just below the roof and surrounds the ground that allows more light and facilitates pitch growth.

The stadium has hosted three full international football matches, one of them involving England. In 2015 it had the honour of providing the venue for three Rugby Union World Cup matches. The biggest attendance was 30,198 as Argentina beat Namibia 64-19. As rugby enthusiasts will undoubtedly know, not a single team from the northern hemisphere reached the final stages of the competition.

As you might expect the reach of the venue extends beyond sport. There are facilities for conferences, meetings, banqueting, weddings and other events. There are regular stadium tours which, for a price, are available to the public.

I have not seen the phrase used but perhaps Leicester City might, until recently at least, be termed the nearly team of English football. They have played in four FA cup finals but never won the trophy, and they have spent lengthy periods fighting for promotion from the second tier or trying to stave off relegation from the top flight. Over the course of its history the club has spent forty-six seasons in the top flight, sixty-two seasons in the second flight and one season in the third flight. They have won the League Cup three times and been runners-up twice. Before 2015/16 their best season was 1928/29 when they were just one point behind Sheffield Wednesday at the top of the old Division 1.

The club was formed in 1884 with the original name of 'Leicester Fosse' and it had five different grounds before moving to Filbert Street. The club joined the Midland League in 1891 and was elected to Division 2 of the Football League in 1894. It got into financial difficulties at the end of the First World War and was reformed as Leicester City Football Club in 1919. Football clubs experiencing financial difficulties is not just a modern phenomenon, though it happens much more now.

Leicester City is not a club that makes a habit of having long-serving managers and there have been fourteen so far this century (correct at the time of writing). The present one is the hugely respected Italian Claudio Ranieri. Since 1919 there have been nine permanent secretary/managers and thirty-four permanent managers. Caretaker managers are not included and both Peter Hodge and Nigel Pearson have had two spells in charge. Leicester are of course far from being the only club to have a dizzying turnover of managers. Most do, though Arsenal is an honourable exception. It was not always thus and, in former years at least, some clubs did it differently. Fred Everiss was secretary/manager of West Bromwich Albion for forty-six years from 1902 to 1948.

This chapter would not be complete without mentioning some of the club's great players. Arthur Chandler netted more goals than any other – 273 in 419 appearances between 1923 and 1934, and they included six in a single game. Arthur Rowley was every goalkeeper's nightmare, scoring 434 goals in 619 Football League games, 265 of which – in all competitions – came in 321 appearances for Leicester. They accumulated over eight seasons and included 44 in 1956/57.

Leicester City has had two of the world's best-ever goalkeepers, with one replacing the other. Gordon Banks played seventy-three times for England, including in every match in his country's successful 1966 World Cup campaign. He joined Leicester from Chesterfield in 1959 and was transferred to Stoke City in 1967. He was still England's first choice goalkeeper in 1972 when his career in England ended due to the loss of an eye in a car crash. His replacement, Peter Shilton, joined Leicester as a schoolboy and played for England 125 times, a record not surpassed by any player. He became Leicester's first choice keeper in 1967 when Banks left, and he played for the club until 1974 when, like Banks, he was transferred to Stoke City.

A mention must also go to the very popular Gary Lineker. He started his career with Leicester and between 1978 and 1985 he scored 95 goals in 194 games for them. It was the club's loss when he was transferred to Everton. Gary scored 48 goals in eighty games for England, a tally only exceeded by Wayne Rooney and Sir Bobby Charlton. In a career that lasted sixteen years, and despite periodic provocation, he was never cautioned or sent off.

Lineker was a Leicester boy and his heart remained in the city. After his retirement he led a consortium that saved Leicester City from bankruptcy and he was made an honorary vice-president of the club. Since his retirement from playing Gary has had and still has an outstanding media career, and of course he will always be associated with Walkers Crisps.

The King Power Stadium is magnificent, but it seems just like many other modern stadiums. I sometimes feel nostalgic for the differing ones that they replaced and for the football that was played in them. As a teenager I watched Leicester City play Sheffield Wednesday at the old Filbert Street ground. I was standing in some degree of discomfort and in the latter stages of the game the fog was so thick that I could only see one of the goals. All the players were from the British Isles and many were local to the clubs that they represented. They lived among the fans that watched them and were paid no more than two or three times the wages of most of the supporters. Of course some may have got under-the-counter money as well, but not very much. As a teenager I had no difficulty affording the charge for entering the ground. Happy days! But would I really like to turn the clock back?

At 9.54 p.m. on Monday 2 May 2016 the city of Leicester and most of the country's football fans exploded with paroxysms of jubilation. Leicester had won the Premiership. With their nearest rivals having just two games left to play they were seven points clear and could not be caught. It was the greatest football shock for decades, arguably surpassing the feats of Sir Alf Ramsey's Ipswich in 1962, Brian Clough's Derby County in 1972 and Brian Clough's Nottingham Forest in 1978.

Leicester had only just avoided relegation at the end of the 2014/15 season and in August 2015 bookmakers were offering odds of 5,000-1. The whole Leicester team cost less than a single player in one or two other clubs. Inspired by their Italian manager, Claudio Ranieri, they played attractive, attacking football and thoroughly deserved their triumph. A particularly noteworthy feature of the season was Jamie Vardy scoring in eleven consecutive league games. Four years previously he had been playing non-league football and nine years previously, following a conviction, he had been playing wearing an electronic tag.

Truly, God is in his Heaven and money is not everything in football.

Welford Road Stadium: Home of Leicester Tigers

Welford Road Stadium is close to the King Power Stadium, the home of Leicester City Football Club, and it can be seen from the same area of the line. It is on the left side of the train, just under a mile before Leicester Station and further away from the line than the football stadium. Welford Road is the home of Leicester Tigers Rugby Club (the Rugby Union variety not Rugby League) and they have played there since 1892. Back then it could accommodate 1,100 spectators.

The rugby stadium has a mixture of standing and sitting areas, unlike the football stadium which is all seating. At the time of writing an expansion programme is concluding and this leaves it able to cater for 30,000 spectators. Unlike the King Power Stadium which was purpose-built, Welford Road has been progressively developed. This results in a less standard and perhaps more interesting environment. Spectators and other visitors are more likely to feel a sense of history.

In 2005 there was a proposal that the football club and rugby club would share the King Power Stadium, then called the Walkers Stadium. However, agreement was not reached because of a difference over priorities. This later led to the decision to expand and improve

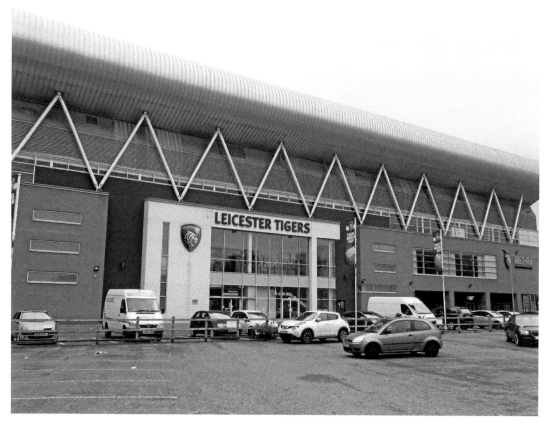

Welford Road Stadium.

the amenities at Welford Road. Like the football stadium it now has extensive facilities for conferences, meetings, dinners, exhibitions and the like.

People associated with the rugby club were disappointed that their ground was not selected to host any matches for the 2015 Rugby World Cup; Gloucester were the only club side to be given the honour. As mentioned in the previous chapter, three of the games were played at the nearby King Power Stadium.

In recent years the Tigers have been the most successful club in England. They play in the Aviva Premiership and they have won it ten times since the introduction of league rugby in 1987. This is four times more than Bath or Wasps, the next most successful clubs. 2013/14 was by their standards rather disappointing, but they won the Premiership in 2012/13 – they appeared in a record nine Premiership finals between 2005 and 2013. The Tigers are one of only four teams that have never been relegated from the top division, the others being Gloucester, Bath and Wasps. They are the only English side to have qualified to play in every Heineken Cup in which English teams have participated and they have also been the most successful English side in Europe. They were champions in 2001 and 2002, and losing finalists in 1997, 2007 and 2009.

One of the keenest rivalries in rugby is the one between Leicester Tigers and their relatively near neighbours, Northampton Saints. The matches are always keenly anticipated, strongly

contested and argued about afterwards. I know all about this because my friend Alan is a very long-standing supporter of the Tigers and my cousin Nick is a very long-standing supporter of Northampton Saints.

Leicester Tigers have been campaigning since the 1880s and they won the Midland Cup every year from 1898 to 1905. They had then moved to Welford Road and they dropped out of the cup to give the other clubs a chance. Despite this the great successes already described have only been achieved in the last thirty-five years or so. At the start of the 1970s the club had just 600–700 members and gates were sometimes less than a thousand, but then things started to look up. They played five times at Twickenham in the final of the John Player Cup. They lost in 1978 and 1983, but won in 1979, 1980 and 1981. The hat-trick of wins meant that they were allowed to keep the trophy.

The game in the 1980s was still amateur, but it was changing and the club made moves towards sponsorship. However, the amateur players had jobs and enjoyed the hospitality of nights away and tours. In 1980 Leicester were the first English club to make a tour in the southern hemisphere. The Tigers developed into being the most consistently successful English side. Until the mid-1990s it was as an amateur club and after that as a professional.

The origin of the name 'Tigers' is not known for certain, but it could have been the nickname of the Leicestershire Regiment, acquiring such a name because of its service in India. The soldiers wore a cap badge that featured the animal.

I played rugby at Aylesbury Grammar School but with little distinction. Since leaving school I have only attended two rugby matches. One was an international at Twickenham and the other, a few weeks after leaving school, was at Welford Road. If my memory serves me correctly the fixture was East Midlands v the South African Springboks – it was a long time before the end of apartheid and the South Africans were all white. The whole match seemed to be one long scrum in a lot of mud and the result was a 3-3 draw. The spectators were delighted because the Springboks were very strong and it was the only game on the tour to date that they had not won. I liked Welford Road, though it is very different now. It obviously made an impression on me because I remember it clearly so many years later.

There is humour in this book, but not so far a straightforward joke. So here goes. As you read the following please remember that England was the host nation for the 2015 Rugby World Cup, and that it was eliminated at the pool stage. This was the only time that this had happened in the history of the competition:

A schoolmaster wanted to get his class talking about the world of work, so he asked them what their fathers did for a living. All responded except one boy who would not say anything. Eventually, and at the urging of the teacher, he said, 'My Dad's an exotic dancer. He works at night and goes to a bar. He takes all his clothes off and does exotic dancing. Usually he comes home at two in the morning but sometimes he stays out all night.' The master was horrified. He set the class some work, then took the boy outside and asked him if what he had said was true. 'No' said the boy. 'He plays rugby for England but I was too embarrassed to say that.'

The joke has merit in that the sport in the punchline can be varied – cricket, football or some other sport will do just as well!

Fosse Way and the River Soar

The River Soar runs between the railway line and the King Power Stadium and it can be seen from the same area as the two sports stadiums. It is not particularly attractive at this place, so this chapter's picture of the river is taken from a point closer to the city centre.

The ancient Roman Fosse Way crosses the River Soar at Leicester and is very much associated with the city. An indication of this is the number of locations that incorporate the word Fosse – Fosse Shopping Park for one. Ten roads and similar include it in their names, and as mentioned in an earlier chapter the original name of Leicester City Football Club was Leicester Fosse.

The River Soar is a significant tributary of the River Trent. A major part of it is canalised, and as can be deduced from the photograph this is the case as it runs through Leicester. The source of the river is midway between Hinckley and Lutterworth. It is linked to the Grand Union Canal at Leicester, then flows on through Loughborough and Kegworth, joining the River Trent close to the Leicestershire–Nottinghamshire border.

The Soar in Leicester and the Leicester Line of the Grand Union Canal were once vital for the carrying of cargo. In fact, they were a significant factor in Leicester's prosperity. Of course those days have long gone and it is now important for leisure purposes. There are narrowboat cruises and the towpaths are used for walking, cycling, horse riding and fishing.

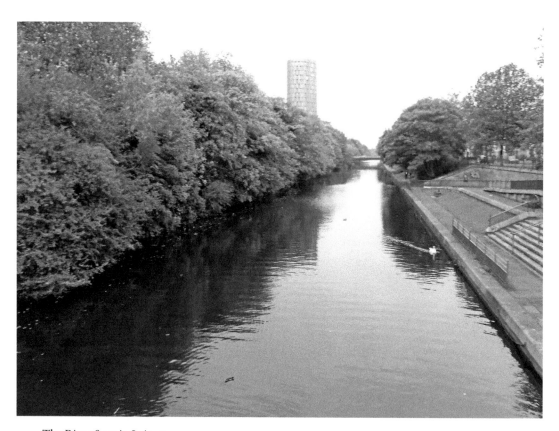

The River Soar in Leicester.

A canalised section of the river through Leicester is known as the 'Mile Straight' and this is the home of the Leicester Rowing Club, which has an annual regatta on the river. Another section of the river is the location of the annual Varsity Rowing Race between De Montfort and Leicester universities.

Fosse Way was a Roman road that linked Exeter in south-west England with Lincoln, which is almost exactly due north of Leicester. The word 'fosse' is derived from the Latin *fossa*, meaning ditch. It was constructed in the first few decades after the Roman invasion of Britain in AD 43 and is one of the very earliest of the Roman roads. It was built to mark what was then the western frontier of Roman rule in Britain. It is possible that it was built as a defensive ditch that was later filled in and converted to a road, but it could be that a defensive ditch ran alongside the road for at least some of its length.

As all schoolchildren should know but perhaps do not, the Romans were famous for building straight roads, going over obstacles, not around them. Fosse Way is the supreme example of this: Ilchester in Somerset to Lincoln is 182 miles and it comprises most of its length. At no point does Fosse Way deviate by more than six miles from a straight line. With the skills to achieve that, no wonder the Romans were so successful.

Several place names on the route incorporate the suffix *cester* or *chester*, which is from the Latin *castra*, meaning military camp. The previously mentioned Ilchester is an example. Other place names are based on the Latin *strata*, meaning street. Examples are Street Ashton, Stretton-under-Fosse and Stratton.

When Fosse Way was built, the settlement at what is now Leicester had the Roman name *Ratae* and the road crossed the river there. At the time rivers were not channelled and deep as they often are now, which helps to explain why the Soar could be crossed. The Roman Watling Street was able to cross the Thames at London for the same reason.

Leicester

If your train from London to Sheffield is a fast one, it is probable that Leicester will be the first stop. It is a city, a unitary authority and the county town of Leicestershire. According to the 2011 census the population of the unitary authority was 329,389, which puts it ahead of Derby as the largest centre of population on the journey. This makes it worth a further chapter in addition to the three preceding ones.

Leicester has a long and interesting history and what follows is a fraction of it. There was an early Iron Age settlement on the site of what is now the city. The Romans arrived in AD 47, and the previous chapter gives an account of Fosse Way and its crossing of the River Soar. Sometime after the Romans withdrew from Britain the city was for a while held by the Danes. In 1086 the Domesday Book, compiled on the orders of William the Conqueror, gave it the name *Ledecestre*. During the Civil War Leicester was a Roundhead stronghold and it was sacked by Prince Rupert for the Royalists.

The city industrialised in the nineteenth century, aided by canal and rail links. Prominent industries were hosiery, textiles, footwear and engineering. It has had the reputation of being a prosperous place, avoiding the worst effects of recessions and depressions.

It is hard to talk about Leicester without mentioning that it is one of the most ethnically diverse places in the UK. There has been large-scale immigration from South Asia (mainly India) since the 1960s, and many Asians came from Uganda and Kenya in the early 1970s.

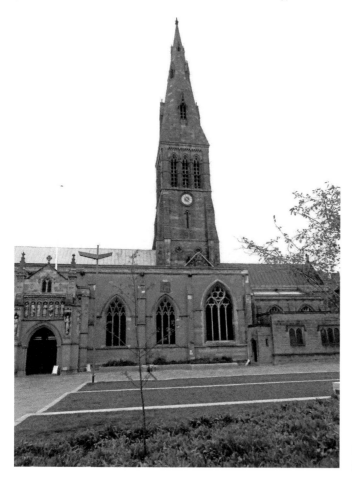

Leicester Cathedral: burial place of Richard III.

In the 1990s some Dutch citizens of Somali origin came, and people have come from other places too.

According to the 2011 census 50.6 per cent of Leicester's population was white, including 45.1 per cent who were described as white British. 37.1 per cent were Asian, including 28.3 per cent from India. These figures can be misleading because people born in Britain may be described as Asian. The same census states that 32.4 per cent described themselves as Christian, 18.6 per cent as Muslim and 15.2 per cent as Hindu. As well as English, seventy languages and/or dialects are spoken in the city. Gujerati is the first language of 16 per cent of the city's residents. It is widely believed that since 2011 the white population has become a minority in Leicester.

The arrival of the Ugandan Asians was very controversial. In August 1972 Idi Amin, the monstrous, brutal and possibly mad dictator of Uganda, gave his nation's 35,000 Asians ninety days to leave the country. The city's council placed advertisements in Ugandan newspapers urging them not to come to Leicester. The text of the advertisements read,

IN YOUR OWN INTERESTS AND THOSE OF YOUR FAMILY YOU SHOULD ACCEPT THE ADVICE OF THE UGANDA RESETTLEMENT BOARD AND NOT COME TO LEICESTER

The councillors maintained that their motives were pure, but it is not hard to see it in a different light. Perhaps predictably the advertisements did not have the desired effect, and in fact they probably had the opposite effect: it made the immigrants think about Leicester, which some of them might not have done. Around 6,000 of them came to Leicester and they were later joined by around another 4,000 who had initially gone elsewhere. It is generally believed that most of them settled well and have been an asset to the country.

Who was the last king of England to be buried? And where and when did the burial take place? Many would say George VI at St George's Chapel, Windsor Castle, in 1952. They would, though, if reburial is counted, be wrong. It was Richard III at Leicester Cathedral on 26 March 2015.

People argue as to whether or not Richard III was a bad king and whether or not he had the two princes murdered in the Tower of London. What is not in doubt is that he was killed not far from Leicester, leading his army at the Battle of Bosworth Field on 22 August 1485. This was the last significant battle of the Wars of the Roses and marked the end of the Plantagenet dynasty. Shakespeare's play has Richard cry out 'A horse! A horse! My kingdom for a horse!'

It was known, or at least believed, that following the battle Richard's body was quickly and unceremoniously buried at the Church of the Grey Friars in Leicester. This was later demolished during Henry VIII's Dissolution of the Monasteries and the precise site was not known. In recent years a city centre car park covered the area.

The story moves on 527 years. The University of Leicester and Leicester City Council, in association with the Richard III Society, launched a search to find the remains of Richard's body. Against considerable odds they succeeded in just a few days. Much circumstantial evidence indicated that who they had found was indeed Richard, and DNA evidence proved conclusive. Comparisons were made with the son of Richard's sixteenth-generation great-niece in the direct maternal line.

Richard was reburied at Leicester Cathedral on 26 March 2015. The Bishop of Leicester and the Archbishop of Canterbury, officiated. The Royal family was represented by the Countess of Wessex and by the Duke and Duchess of Gloucester. The actor Benedict Cumberbatch is a very distant relative of the late monarch, and he read a poem by Poet Laureate Carol Ann Duffy. The king's remains are in a lead ossuary inside an English-oak coffin. They were placed in a vault below the floor of the cathedral.

Leicester Cathedral, which is a Grade II listed building, is shown in the photograph for this chapter. It is best known as the burial place of Richard III, but it is worth a visit for other reasons too. A church dedicated to St Martin has stood on the site for over 1,000 years. Parts of the present building can be dated back to that time, but over the years there have been a number of restorations and the addition of a spire. Most of what can be seen today is Gothic in style and the result of a major Victorian restoration. There are four separate chapels, one of them containing memorials to the men of the Royal Leicestershire Regiment and the regiment's battle honours. The names of those killed in the Crimea, South Africa and the two world wars are recorded there.

Particularly interesting is one of the windows. It shows a sunlike orb with cherubs radiating away from it. In the centre Jesus sits holding a starry Heaven in one hand and with one foot on hell. Surrounding Jesus are eight angels whose wings are made from red glass. To the far right stands St Martin with his foot on the tail of a dragon. St George is standing on the head of the dragon. In a row at the bottom are St Joan of Arc, Mary, Jesus with crying angels, Mary Magdalene, James and St Martin of Tours. A First World War soldier is in the window.

It should of course be mentioned that Leicester Cathedral should not be viewed as just an interesting location, redolent with historical associations. It certainly is that, but it is also an active place of Christian worship. During my visit a banner outside proclaimed 'REFUGEES AND THEIR FAMILIES ARE WELCOME.'

Ratcliffe-on-Soar Power Station

This has to be the easiest to spot of all the sites featured in this book, and unless you are asleep you will not miss it. The power station has eight massive cooling towers and a 653-foot-tall chimney. They dominate the countryside for miles around, and are on the right side of the train, next to the track and next to East Midlands Parkway Station. It is roughly two thirds of the way between Leicester and Derby. The site is in Nottinghamshire, but within half a mile of both Leicestershire and Derbyshire.

Ratcliffe-on-Soar was built in in the 1960s and commissioned in 1968 by the then Central Electricity Generating Board. It is coal-fired and has an output of 2,116 mw, which is enough to meet the needs of 2 million homes. Cooling water is taken from the nearby River Trent. In 1981 the station burned 5.5 million tonnes of coal a year and took 65 per cent of the coal mined in South Nottinghamshire. Coal mining in Britain has now virtually ceased and all the coal is imported.

Coal-burning power stations do not have a favourable impact on the environment and e.on, which operates Ratcliffe-on-Soar, is keen to make it known that it has taken effective measures to minimise the harmful effects. These have included the fitting of Flue Gas Desulphurisation Equipment that removes around 92 per cent of the sulphur dioxide. There is also a Boosted Over Fire Air System to reduce oxide of nitrogen emissions. I could go on but your eyes are probably at risk of glazing over, so I will just also mention that High Efficiency High Pressure Turbines are used in each of the generation units to improve efficiency and reduce carbon dioxide emissions.

The above measures enable the plant to comply with the Large Combustion Plant Directive issued by the European Union. This aims to reduce acidification, ground-level ozone and particulates, by controlling the emissions of sulphur dioxide, oxides of nitrogen and dust from large combustion plants. The whole area is managed with an eye on

Ratcliffe-on-Soar Power Station.

biodiversity. Three bird species that are globally threatened are found there – bullfinch, linnet and song thrush – as are badgers, foxes, weasels and brown hare. All this information is made available by e.on. It sounds like paradise and an ideal place for a picnic.

Despite all this, the power station has not escaped the attention of environmental protesters. In 2007 eleven activists were arrested after they entered and climbed on to equipment. In 2009 police arrested 114 people who were believed to be planning to disrupt the running of the plant – twenty-six of them were later charged with conspiring to commit aggravated trespass. Some were convicted but the convictions were later quashed when it was discovered that a police officer working as an undercover infiltrator had played a significant role in organising the action. Later in the same year several hundred people pulled down security fencing and a number were injured.

Ratcliffe-on-Soar Power Station is nearly fifty years old, which makes it quite elderly. Regardless of this, and unless there is a change of mind at government level, its days may be numbered. This is because it is possible that all Britain's coal-fired power stations will close by 2025. It will be done for environmental reasons, leaving the country dependent on gas-fired plants, nuclear and renewable energies. However, an exception will be made for coal-fired stations that by 2023 are able, to an acceptable standard, capture and store their carbon emissions. Ratcliffe-on-Soar may be able to meet these conditions and have a longer life.

The chapter concludes with a comment from your writer. The country is perilously close to enduring a shortage of electricity at peak times. It is not inconceivable that the lights might go out, or at least that the country might endure 'brown-outs'. Let us hope that the government does not mess up.

The iPro Stadium:
Home of Derby County Football Club

The four sites covered in this and the next three chapters are all within a distance of a mile and a half, and all are close to the centre of Derby. The train will probably stop in the centre of the city so you should be able to see them all easily. This one and the next are in Pride Park, close together on the right side of the train; they can be seen from a low embankment on the approach to the station.

Irritating as it may be, we must honour the sponsor and give the stadium its correct name. It was previously called the Pride Park Stadium. Derby County Football Club moved into it in 1997 and it was opened by the Queen in July of that year. It is an all-seater stadium with a capacity of 33,597 spectators, which makes it the twentieth largest of any sports stadium in the United Kingdom. Its design is based on that of the Riverside Stadium in Middlesborough and the final cost was £28 million. The pitch size is 105 metres by 68 metres.

Things are now looking reasonably bright for the club, but since Her Majesty opened the stadium it has not always been smooth sailing. There was a most unfortunate start when a floodlight failure caused the first competitive game there to be abandoned part way through the second half. There was a financial crisis after relegation from the Premiership at the end of the 2001/02 season. The company went into administration and then the ground was sold to a Panama-based corporation. The club had to pay a £1 million a year

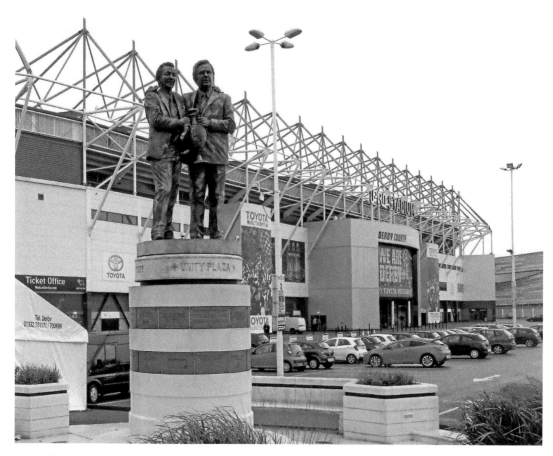

The iPro Stadium with the statue of Brian Clough and Peter Taylor.

to use it – something that greatly annoyed the supporters. Then things looked up. A group of local businessmen acquired the ground and it was returned to the club. The businessmen were dubbed locally as 'The League of Gentlemen'.

Since 2002 the club has only spent one season in the Premiership – 2007/08 – and it was a disaster. They only managed one win in thirty-eight games and their tally of eleven points is the lowest since the Premiership was founded in 1992. On a brighter note, the club has hosted a full England international fixture. Its form in the Championship has been mixed, but crowds have been good. In 2008/09 when they finished eighteenth the average was 29,445, and in 2014/15 when they finished eighth it was 29,234.

By any standard the iPro Stadium is superior to the Baseball Ground, which was the club's old home, but despite this some of the older fans feel a little nostalgic for the former stadium. As the name suggests, it was originally used for baseball, and then it was the home of Derby County Football Club from 1895 to 1997. Modern football stadiums sometimes seem much the same and lack the atmosphere of the ones they have replaced.

The length of the pitch at the Baseball Ground was five yards less than the current ground, and the width was four yards less. Some would say that it was compact, but others would say that it was small. The front section of the crowd was very low down and close to the pitch,

a situation that could lead to the players being launched into the spectators. The drainage was often poor and it was one of the muddiest pitches in English football. Old photographs often show the games being played on surfaces that would not be tolerated now. Nostalgia can be a wonderful thing, but perhaps we should celebrate what we have now.

Derby County Football Club was formed in 1884 and in 1888 it was one of the founding members of the Football League. It has had, and still has, a reputation for being very well supported. You will probably know that I mean when I say that Derby was and is a football town, although I should now really say a football city. The glory days were in the 1970s, but it should be mentioned that the club won the FA Cup in 1946. It was the losing finalist in 1898, 1899 and 1903.

A visit to the iPro Stadium is bound to include an inspection of three statues, one inside the ground and two outside. The one inside is a bust of Steve Bloomer, reckoned by many to be Derby's greatest ever player. The anthem *Steve Bloomer's Watchin'* is played at every home game.

Bloomer played his first game for Derby in 1892 and his last in 1914 at the age of forty. In the intervening years he scored 289 goals in 473 appearances for the club, and an extraordinary total of 28 goals in 23 appearances for England. In 1906 he was transferred to Middlesbrough because the club was short of money, but he rejoined Derby in 1910. As well as his Derby and England goals he scored 61 in 125 appearances for Middlesbrough. Bloomer was coaching in Germany at the outbreak of the First World War and he was interned there. As well as being Derby's best player he was a great player for his country. England could do with him now.

The photograph accompanying this chapter shows the statue of Brian Clough and Peter Taylor outside the iPro Stadium. The statue was designed by the sculptor Andrew Edwards, who was also responsible for the Steve Bloomer bust. The name Clough is indelibly associated with Derby County and he achieved much there and elsewhere. With Peter Taylor as his assistant he managed the club for six years. He was outspoken, controversial, outrageous, entertaining and a household name.

In 1967 at the age of only Clough became manager of Derby County and Peter Taylor joined him as his assistant. In 1968/69 the club were champions of Division 2 and in 1971/72 Derby were champions of Division 1. The following season they reached the semi-finals of the European Cup. Then the board and the chairman in particular became dissatisfied with Clough's autocratic ways and his very high and controversial media profile. Clough and Taylor resigned.

Clough, with Taylor as his assistant for part of the time, later managed Nottingham Forest for eighteen years. They had even greater success there. In the early years the team gained promotion from Division 2 and were then champions of Division 1. They went on to win the European Cup in successive seasons and won the League Cup four times.

There are so many Brian Clough quotes that we are spoiled for choice. Here are two of them: 'I wouldn't say that I was the best manager in the business, but I was in the top one,' and 'At last England have appointed a manager who speaks English better than the players' (this was following the appointment of Sven Goran Eriksson as England manager).

Brian Clough is chiefly remembered for his exploits as a manager, for his outrageous behaviour and for his media activities. However, his achievements as a player should not be overlooked. In 274 league games for Middlesbrough and Sunderland he scored 251 goals, including 40 or more in four successive seasons, giving a remarkable average of 0.91 per game. Steve Bloomer averaged 0.61 per game for Derby.

Brian Clough died in 2004. Sadly, the end of his story is in many ways an unhappy one. He had been a heavy drinker since the 1970s and became an alcoholic. He and Peter Taylor quarrelled badly and the pair had not been reconciled when Taylor died in 1990. Clough went to the funeral and afterwards showed many signs of regretting the dispute. Taylor had returned to Derby as manager for seventeen months in 1982.

Clough and Taylor are fondly remembered in both Derby and Nottingham. The A52 road between the two cities is named 'Brian Clough Way'.

The third statue is also by Andrew Edwards. It honours Dave Mackay and was unveiled in 2015 shortly after his death. He was a great player for Hearts and Tottenham Hotspur, and he played for Derby under Brian Clough. Mackay managed Derby from 1973 to 1976 and was in charge when the club won the Division 1 title for the second time.

At the end of the 2015/16 season Derby County participated in the play-offs, but did not secure promotion to the Premier League.

Derby Velodrome

The Derby Velodrome is more correctly termed the Derby Arena, but it is very widely known as the Derby Velodrome and this is the name used in this book. It is in Pride Park, Derby, and just a couple of hundred yards from the iPro stadium. It can be seen on the right

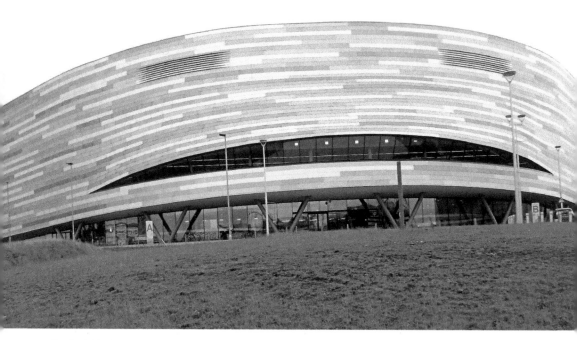

Derby Velodrome.

side of the train during its approach to Derby station. As can be seen from the photograph it has a distinctive shape and it is coloured yellow. It should be easy to see.

As you very probably know but I had to check, a velodrome is an arena with a banked track for cycle racing. I suspect that the word is derived from velocipede, which was an early form of bicycle. It is, though, more than that, and it goes under the name of the Derby Arena. It was financed by Derby City Council and opened in March 2015. It cost £28.5 million and including the central area it seats 5,000.

The interior is of a size capable of taking thirteen badminton courts and badminton is indeed one of the sports played there. Basketball is also played there and it has a large and well-equipped gym. It is suitable for concerts and there is an annual Christmas pantomime.

Cycling is a good thing. We know that because the government tells us so and surely the government must be right. It is good for our health and good for the environment, and has enjoyed something of a boom in recent years. There has also been a boom in competitive cycling and Britain has been very successful, especially in events as famous as the Olympics and the Tour de France.

The velodrome is to accommodate the boom in competitive cycling and to encourage cycling generally, and Derby hopes to establish itself as the centre of the sport in Britain. The track was made from twenty-six miles of timber taken from Russian spruce forests in Siberia. It is Britain's fifth 250-metre indoor track and it is fast. We have the word of no less a person than the great cyclist Sir Bradley Wiggins, who has said that Derby Arena is a world-class track suitable for world record attempts. He hopes to make some himself.

I came away from my Sunday morning visit feeling uplifted, and this was not solely due to the tax-deductible refreshments that I enjoyed. Thirty or so cyclists were training and circulating at a frightening speed. I did not see it but I was told that quite young children do exactly the same. People were using the gym and eight of the thirteen badminton courts were in use.

The Roundhouse at Derby

Wolverton is recognised as the world's first so-called railway town. A tiny village was expanded to provide workshops and workers for the London to Birmingham Railway which opened in 1837. I tell its story in *London to Birmingham by Rail*, which was published by Amberley in 2013. The railway workshops in Derby opened in 1839 and the town, now a city, has a claim to be the second railway town. However, unlike Wolverton, it was already a significant town, so it would perhaps be misleading to do so. This chapter tells of the fascinating railway heritage that can be seen from the train at Derby.

A number of buildings collectively known as the 'Roundhouse' are around 100 yards from the station on the right-hand side and can very clearly be seen. The actual Roundhouse, which is shown in the photograph, is the jewel in the crown and is part of the complex. It is best seen from the beginning part of the station. It is a Grade II listed building and with other associated buildings on the site it was sympathetically restored and repaired in 2008.

Details of the buildings and how they are now used come later in this chapter, but an account of their railway use and Derby's railway history cannot fail to be of interest. The early frenzy of railway development saw four railways open at Derby in 1839 and 1840.

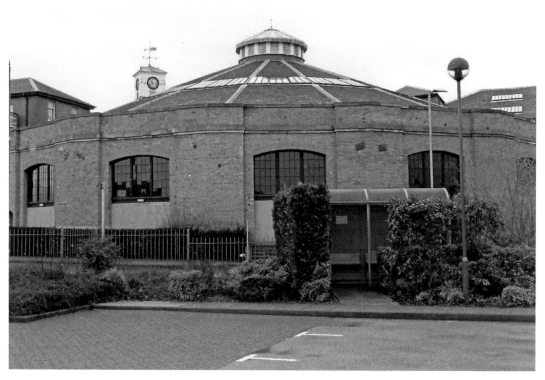

The Roundhouse.

One of them was the North Midland Railway, for whom George Stephenson and his son Robert were engineers – it was Robert Stephenson who was responsible for the Roundhouse. It opened in 1839 and Derby station followed in 1840. As its name implies, the Roundhouse is round and was constructed in this way to enable engines to be turned within it. The function of the building was the repair of locomotives.

The Roundhouse was 190 feet in diameter and the height of the dome-shaped roof was 50 feet. It contained sixteen lines of rails radiating from a single turntable in the centre. On arrival engines were taken to the turntable and then transferred into a vacant stall. Each of the sixteen stalls could contain two or three engines at any one time.

Inspired by George Hudson, the disreputable so-called 'Railway King', the railway companies merged in 1844 to create the Midland Railway Co. with Derby as its headquarters. This of course created a need for offices next to the Roundhouse and the station.

Over the succeeding years there was a great expansion in railway activity in Derby and the individual workshops merged to become the Midland Railway Locomotive Works. Building engines started in 1851 and in 1873 the work had expanded to such an extent that the Derby Carriage and Wagon Works was moved to another site and the Locomotive Works remained by the station. Additional roundhouses were built and by 1900 the Locomotive Works had 4,500 employees. The main business was maintenance and repairs but it built forty new engines each year. All this was in addition to the building, repair

and maintenance of carriages and trucks. In 1894 more than 8,000 railway workers were employed at Derby and the works covered eighty acres, twenty acres of which were covered. As all schoolchildren should know but don't, there are 4,840 square yards in an acre. This means that Derby County's ground at the iPro Stadium would fit into the twenty covered acres nearly twelve and a half times.

The Midland Railway became part of the LMS in 1923, and this in turn was part of the nationalised British Railways in 1947. The Derby Works became part of British Rail Workshops. The first British mainline diesel locomotive was built in Derby in 1948 and engine production ceased in 1966. Over the years 2,941 steam engines and more than 1,000 diesel locomotives had been built there. In 1980 most of the locomotive works were demolished, but the story has a happy ending.

In 2008 the Roundhouse, Engine Shed and Carriage Shop were sympathetically restored and repaired. There are also new newly constructed buildings which have been designed to blend in with the existing structures. A number of innovations were incorporated, including a 'chamelon-glass' that changes colour depending on the light and angle of view. The turntable is still in the Roundhouse.

The whole site is part of the campus of Derby College. The Roundhouse itself provides the focus and social hub of the college campus and is open to the general public through guided walk events and by prior arrangement as well as students. It is also a wedding venue. The adjacent Carriage Shop houses the library and learning resources centre and a multipurpose theatre. The Engine Shed accommodates the new training restaurant.

Booking is essential for tours. The contact is Derby Information Centre tel: 01332 255802 or book online at www.visitderby.co.uk/derbytours.

Just one more thing – Guinness World Records acknowledges Derby Roundhouse as the oldest in the world. Wolverton is the world's first railway town, but it cannot match that.

Cathedral Church of All Saints, Derby

The tower at Derby Cathedral is fifty square feet at the base and rises to a height of 212 feet. There is nearly always a flag flying at the top. The cathedral is in the centre of Derby and it is probably fair to say that it is the city's most prominent landmark. In the summer in recent years it has been the home of nesting peregrine falcons. It is on the left side of the track and can be seen shortly after the train leaves Derby station.

The tower was built in the early 1500s and was completed around 1532, so it has dominated the city (town until 1977) of Derby for almost half a millennium. It is known that 'Ales' were held in that year to raise money for the final work. Special ale was brewed and cakes baked. The feasting was accompanied by morris dancing, sports and the presentation of mystery plays. The words 'Young Men and Maidens' are carved along the string course of the south face. They are taken from Psalm 148 and are thought to indicate that the young people of the town paid for the first stage of the building.

It is believed that a preceding structure on the site was founded by King Edmund in 943 as a royal collegiate church. Early in the twelfth century Henry I made a gift of it to Lincoln Cathedral. No signs of the earlier church or churches remain, but a later one was built during the fourteenth century.

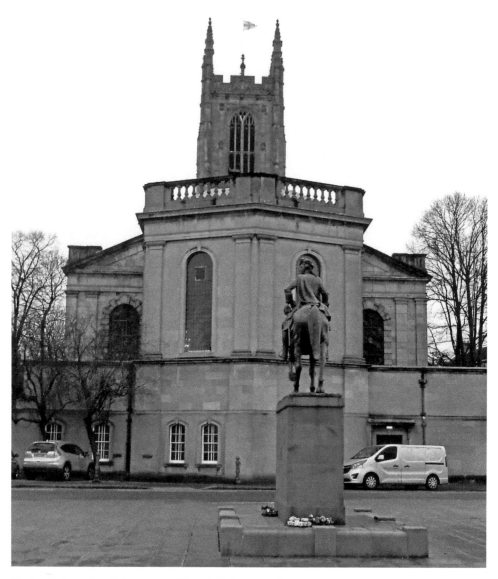

Derby Cathedral and the statue of Bonnie Prince Charlie.

This chapter and others in the book praise various churches and our forefathers and foremothers (if there is such a word) who built them, maintained them and used them over so many centuries. Nevertheless, we should not overlook the fact that a few people were appallingly bigoted and a few were violent, probably with the genuine belief that they were observing God's will. What happened at Derby in 1556 is an appalling example. Joan Waste, a poor blind woman living in the parish, went every day to the church where the New Testament would be read to her. She would not accept the doctrine of transubstantiation and under the reintroduced heresy laws was burned as a heretic.

From the middle of the seventeenth century the fabric of the church deteriorated and by 1723 it was in a ruinous state. The church was then demolished and a new one was erected in its place, this one linking to the retained tower and porch. The first sermon was preached in the new building in 1725. Subsequent to this the new building was expanded, and there were changes and a number of improvements made. Finally, an eastern extension was completed as recently as 1972. The church had been hallowed as a cathedral in 1927.

As you would expect with a cathedral of its size and history, a visit reveals numerous objects and stories worthy of inclusion in this chapter, but there is room for only a few. The first is a memorial to Sir William Wheeler, who died in 1666. It is on the wall of the north aisle and is complete with a skull and an hour glass. Sir William came from London to Derby to try and avoid the plague, but he nevertheless died of it. His poignant epitaph reads (in Latin) 'He changed his dwelling place but not his fate.'

Bess of Hardwick (1527–1608), correctly styled Countess of Shrewsbury, is buried in a vault in the cathedral. Her second husband was Sir William Cavendish and one of their children became the 1st Duke of Devonshire. Due to this connection no fewer than forty-four Cavendish coffins occupy vaults in the cathedral. One of them is occupied by the remains of Georgiana, Duchess of Devonshire, whose story may be familiar because of the 2008 film starring Keira Knightley.

Bess died a fabulously wealthy woman and she wanted to be remembered in the way that she chose. Determined to achieve this, the monument in the cathedral was built under her supervision prior to her death. Bess came from minor gentry and grew up in what may be described as genteel poverty. She was a talented, determined, clever and influential woman, but most of her wealth came from her four marriages. She was widowed four times. Her first marriage was to Robert Barlow and it was made for dynastic reasons when she was around fifteen years old and her husband a year older. He died after a year and left her respectably provided for. Her second marriage was very different. It was made to Sir William Cavendish and this enabled her to be styled Lady Cavendish. She was twenty and her husband was twice her age. He died after ten years, during which time they had eight children. At the age of thirty, Bess was a very wealthy and influential widow. Her third marriage, made at the age of thirty-two, was to Sir William St Loe. He was very wealthy and very highly regarded by Queen Elizabeth I, and it was the Queen who chose their wedding date. When Sir William died, after six years of marriage, he left his entire estate to Bess. Her fourth and final marriage, made at the age of fortyone, was to the 6th Earl of Shrewsbury, and this one took her to the peak of society. Once again she selected someone who was extremely wealthy and, furthermore, her husband was the highest ranking nobleman in England. Queen Elizabeth gave them responsibility for the semi-imprisonment of her cousin Mary, Queen of Scots. They fulfilled this duty for nearly seventeen years. The marriage became increasingly unhappy and they eventually separated.

Bess was widowed for the last time at the age of sixty-three. She did not go into a genteel decline but maintained her many interests, including building interests – one of her creations was Hardwick Hall, which is eight miles south-east of Chesterfield and not far from the railway line.

The south wall contains a tablet commemorating the bicentenary of the visit of Charles Edward Stuart in December 1745. He is also known as the Young Pretender and as Bonnie Prince Charlie. A statue of the mounted Charles is outside the rear of the cathedral and this can be seen in the photograph that accompanies this chapter. Charles was the grandson of King James II of England and VII of Scotland. His grandfather had been deposed in the

Glorious Revolution of 1688 and was the last Roman Catholic monarch to reign over the kingdoms of England, Scotland and Ireland.

Charles, aged just twenty-four, landed on the west coast of Scotland in July 1745 in order to lead a campaign to claim the throne for his father James Francis Edward Stuart, known as the Old Pretender. Charles was accompanied by just nine men and a small quantity of arms. He had been promised French money and French troops to aid his campaign. The money arrived but the troops never did. Undeterred, Charles gathered an army of Scottish supporters and commenced a march on London. His cause was a forlorn one and the prospects of success were always slim, but he made progress. Edinburgh surrendered to him with little resistance and he defeated a government army at the battle of Prestonpans. Carlisle fell to him and in December his army of around 6,000 men reached Derby. Here, faulty intelligence reached his council that a large English army was massing ahead of them. It was not correct but the council overruled Charles's objections and decided to retreat – the most southerly point that they had reached was Swarkestone Bridge near Derby.

Bonnie Prince Charlie's men retreated all the way back to the highlands of Scotland, but won the Battle of Falkirk Muir on the way. He was finally and decisively beaten at the Battle of Culloden near Inverness on 16 April 1746. It only lasted forty minutes and was the last battle fought on British soil. Charles evaded capture and was a fugitive for several months. Despite a reward of £30,000 offered for his capture, he eventually escaped back to France.

Inevitably there is a lot of history in this chapter, but we should not forget that there is a great deal going on now. Four services are held each Sunday and three on each of the other days of the week. There are numerous other events, a library and of course a café. No active church, let alone a cathedral, would be complete without a café.

The Church of the Crooked Spire in Chesterfield

The crooked spire is positioned above the church of St Mary and all Saints in Chesterfield. The town is seventeen miles beyond Derby and the travelling time from it to journey's end in Sheffield is around ten minutes. The spire is in the centre of the town and close to the line. It is just before Chesterfield station and can very clearly be seen from before the station, at the station and after the station.

The crooked spire is said by some to be 'the most famous architectural distortion north of Pisa', and with this in mind I was greatly looking forward to my visit. Such expectations are often disappointed, but not this one. Both the spire and the church exceeded them. My visit was on the shortest day of the year and in heavy rain, and the photograph was taken in these conditions, but both the spire and the church were very impressive, more impressive than I had been led to believe.

The church deserves a thorough description but it is the spire that is world famous, so an account of this comes first. It was added to the church in the fourteenth century, most likely around 1362. The tip is 228 feet (69.5m) above the ground. Calculations made in 1999 show that it leans 8 feet 8 5/8 inches (2.657m) south and 3 feet 9 1/8 inches (1.147m) west.

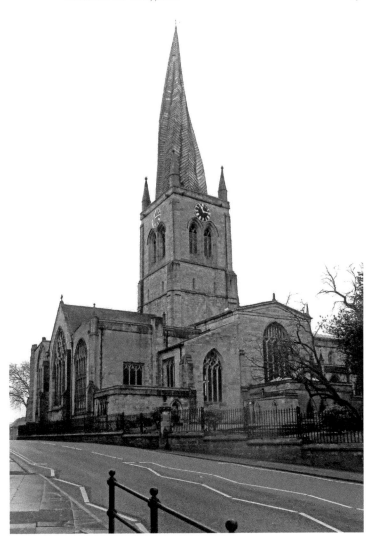

The church of
St Mary and All
Saints in Chesterfield.

The effect is heightened by the lead plates being laid herringbone fashion so the whole spire looks channelled, although the eight sides are in fact perfectly flat.

The exact reason for the spire being crooked is not known, nor is it known if it was made that way deliberately. There are local legends involving the devil and virgins, but they are too silly to recount here. The most likely reasons involve unskilled craftsmen and the use of unseasoned timber, which was common practice at the time. This could have caused one of the main supports to split, making the spire gradually tilt and bulge. Another possibility is the lead that covers the spire. The south-facing lead would heat up and expand more than the north-facing lead. This could lead to twisting. Perhaps it was a combination of factors?

It is possible, but not certain, that the Christian faith came to Chesterfield in Roman times. Be that as it may, there was definitely a church in the town during the reign of Edward the Confessor (1042–66). So it was there at the time of the Norman Conquest. The present church was begun in the thirteenth century. Work began on the tower and the

south transept early in the fourteenth century, and by 1360 the main part of the church was completed. The style is known as Decorated Gothic.

Around 1500 further building was carried out and the roof was raised to its present height, and shortly afterwards the west front was rebuilt. In 1769 the north transept was rebuilt and there have been a number of restorations, the most notable being begun in 1843 under the direction of the great architect George Gilbert Scott.

The church of St Mary and All Saints is a Grade I listed building and it is big as well as impressive. It is, in fact, the biggest church in Derbyshire, bigger even than Derby Cathedral.

Prominent in the memories of my visit are the stained-glass windows. As already mentioned the day was short, dark and wet, but they nevertheless seemed to dominate the interior of the building. The guidebook lists sixteen of them, the oldest being the Maynard Window created in 1868 and the newest the Anniversary Window by Graham Pentelow in 1986. It was given by the people of Chesterfield to celebrate the 750th anniversary of the church. It traces the history of the town from the eleventh century up to the present day.

The main body of the window depicts nine scenes, from a Norman village in the top left to the modern town in the bottom right. Of particular interest to me was the scene based on the arrival of the railway pioneer George Stephenson and his steam engines. He made an impression on the town and his statue stands outside the railway station. Presiding over the top of the nine scenes is the Shield of the See of Derby. Immediately below it are the crown and the palm leaves of All Saints and the pierced heart symbol of St Mary, patron saint of the church.

Ten church bells were installed in 1820, replacing the older ring of eight bells and a small shriving bell. This medieval hundred-weight bell was known as the curfew bell, its name deriving from the fact that between 1804 and 1814 it was rung at nightfall to summon French prisoners of war to their quarters. The bells featured in an interesting dispute in 1829. It had been common for the bells to be rung for secular purposes, but the vicar prohibited it to be done for the Chesterfield races. This upset many people but the vicar prevailed. In 1947 the bells were recast and rehung in a steel frame. This was necessary because of the state of the wooden frame and concern for the spire.

When visiting an old and historic building it is interesting to seek out the oldest artefact. In this church that is the font that can be found in the south transept. This is possibly pre-Conquest, which of course means pre-1066. So it could be 1,000 years old or more. At some unknown time it was removed from the church, but it was rediscovered in 1898 when it was dug up in the vicarage garden. How fortunate and how irresponsible of some of our forebears to lose it. Not surprisingly it is in poor condition, but it is there.

Since 1756 the church has accommodated two organs, the first being inaugurated in that year. It was built by Snetzler of London, a German, and it cost £500. This was a lot of money at the time. The sum was raised by the 'voluntary contributions of some Noblemen and Gentlemen'. It was a fine instrument and it was subsequently resited, reconstructed and enlarged eight times. Sadly in 1961 it was virtually destroyed in a disastrous fire which badly damaged much more than the organ. The replacement organ, which is currently in use, was inaugurated two years later – the well-known 1905 Lewis organ, which had been purchased from the City Hall, Glasgow. This had fifty-six stops and 3,520 pipes and has subsequently been improved.

The upkeep of such a large and splendid church of course comes at a cost. A notice says that it takes £2,533 a week, which is rather a sobering thought. No doubt contributions are made by the coffee shop, the gift shop and tours of the tower, though they would only

be able to provide a modest part. Tours to the base of the spire are available on most days (Sundays and Good Friday the exceptions) from Easter to Christmas.

During my visit I rapidly realised that the church is not just a relic from the past. It hosts a thriving Anglican community and is open from 9.00 a.m. Monday to Friday. The last words come from the church's guidebook:

> Those who visit the church find beneath the spire a vast and impressive building, which for nearly 800 years has been a centre of Christian worship.

> Here prayer has been offered day by day, in good times and in bad. Here the people of Chesterfield have come to celebrate the Christian sacraments. And here visitors are invited to enjoy this oasis of peace in a rushed world and add to it in the stillness of their own heart's prayer.

Sheffield

A few minutes after leaving Chesterfield you will reach the outskirts of the city of Sheffield. Its name derives from the River Sheaf that runs through it, and it is situated at the most southerly part of Yorkshire. It is one of the country's largest cities with a population of

A Sheffield supertram.

563,749 (mid-2014 estimate). The metropolitan population of Sheffield is 1,569,000. It is hilly and is sometimes said to be like Rome, built on seven hills.

If you are familiar with the writings of George Orwell, you may not approach it in a positive frame of mind. In *The Road to Wigan Pier*, published in 1937, he wrote, 'Sheffield, I suppose, could justly claim to be called the ugliest town in the old world.' This may have been true or more likely indicative at the time, but it is certainly not what you will find now. The old ugliness has gone. Apart from anything else 61 per cent of the city is green and a third of it lies within the Peak District National Park.

Sheffield's heritage as a centre of steel production had a lot to do with Orwell's unfavourable comment. Industries have their origins in particular places for a reason, and in this case it had a lot to do with plentiful local supplies of iron, coal and water. During the 1740s a form of the crucible steel process was discovered there that allowed the manufacture of a better quality of steel. Around the same time a technique was developed for fusing a thin sheet of silver onto a copper ingot to produce silver plating, which became known as Sheffield Plate.

Sheffield's steel had a very fine reputation for a long time and many innovations originated there. The city suffered badly in the recession of the 1930s, but it was greatly helped by rearmament in the latter part of the decade. Not surprisingly it was the target of German air raids in the Second World War. Buildings were destroyed and 660 people were killed in what became known as the Sheffield Blitz.

The great decline in employment in the city's steel industry was memorably illustrated in the film *The Full Monty* released in 1997. It tells the fictional story of six unemployed Sheffield steel workers who put on a male striptease show. Such desperate but greatly entertaining measures would not be necessary now. New jobs have come to the city and it is doing well.

A surprisingly little known story of a tragic incident in Sheffield's past deserves to be told. This is the collapse of the Dale Dyke Dam at Bradfield, a few miles from the city. This was built for the Sheffield Waterworks Company and it gave way while being filled in 1864. It happened suddenly, at night, and more than 690 million gallons of water surged into the Loxley and Don valleys and on towards the city. The reservoir was empty within forty-seven minutes. The flood killed at least 240 people. One of the victims was a two-day-old baby and eleven members of one family perished. Even worse was to follow because around another sixty or more died afterwards because of disease caused by stagnant water.

There are many further things that could be described in this chapter; they include Sheffield University, Sheffield Hallam University and the Meadowhall Shopping Centre. There is also the Crucible Theatre, home of the most prestigious event in world snooker. Sporting references would involve Sheffield Wednesday and Sheffield United Football Clubs, and also that the world's two oldest football clubs were formed in the city and that one of them plays at the world's oldest football ground. Space does not permit this, but the chapter does go on to give an account of the Supertram and interesting events in local politics in the recent past.

Nearly all of Britain's trams were phased out after the Second World War, the much loved and nostalgic ones in Blackpool being an exception. In recent years a number of cities have reintroduced them, and Manchester, Edinburgh and Sheffield are three that have done so. Sheffield was so proud of them that the system was immodestly named SUPERTRAM. The photograph accompanying this chapter shows one of the trams whose official name is the Stagecoach Supertram.

Rather like the requirement when the railways were built during Queen Victoria's reign, an Act of Parliament was needed, and this was obtained in 1985. The system opened in stages in 1994 and 1995 and was originally run by South Yorkshire Supertrams Ltd, but it was sold to Stagecoach in 1997. It has a mix of on-street running, reserved right of way and former railway alignment, and it is powered through twelve electrical substations.

There are currently three routes radiating from the city centre and they have a total of forty-eight stops. However, a tram-train line from Cathedral to Rotherham Parkgate is scheduled to start operating in 2017, and there are plans to build a new line from Meadowhall to Dore.

The city of Sheffield has had the reputation of being a Labour Party stronghold, though the Liberal Democrats controlled the council from 1999 to 2001 and from 2008 to 2011. During the early 1980s the council had the reputation of being extremely left wing, and it was dubbed the 'Socialist Republic of South Yorkshire'. The city was declared to be a nuclear-free zone, and a friend who once lived in Sheffield has told me that he recalls the hammer and sickle flying over the City Hall. During this time the council was led by David Blunkett (now Lord Blunkett).

David Blunkett was and is an extraordinary man. He was born blind, came from a poor family and grew up in a deprived part of Sheffield; his father died in an industrial accident when he was twelve. Blunkett became Sheffield's youngest-ever councillor at the age of twenty-two. He later became a Labour Member of Parliament and his views moved a long way from the far left. He held three different cabinet positions in Tony Blair's government.

During the time in question Sheffield council had a policy of vastly subsidising bus travel so that passengers could almost travel for free. The aim was to discourage car journeys and reduce traffic congestion. My friend's friend regularly commuted to his senior city centre job by car, but felt rather bad about contributing to congestion and pollution. So he decided to give the buses a try. At 7.00 a.m. he boarded a bus wearing his normal very smart business suit and carrying his briefcase. On being offered the fare the driver said, 'It's swine like you who stop working men using the buses.'

Journey's End: Sheffield Station

If your journey is on one of the quickest trains, you can expect to arrive at Sheffield a fraction over two hours after leaving St Pancras International Station in London. St Pancras International is splendid and with its famous associated hotel justifies taking the first three chapters of this book. Sheffield Station is not remotely in the same class, but it is adequate and acceptable.

Sheffield station, formerly Pond Street and later Sheffield Midland, is a combined railway station and tram stop. Managed by East Midland Trains, and with nine platforms, it is the busiest station in South Yorkshire. Each hour East Midlands despatches two trains to London, one to Norwich and one to Liverpool via Manchester. Other companies using it are CrossCountry, First TransPennine Express and Northern Rail. Destinations served are as far apart as Edinburgh and Penzance. In 2014/15 the annual passenger usage was 9.113 million.

Sheffield station was opened in 1870 by the Midland Railway, and it was the fifth and last one to be opened in the Sheffield city centre. The power of the landowning aristocracy

The spectacular sculpture outside Sheffield Station.

is illustrated by the fact that the Duke of Norfolk, who owned land in the area, was able to insist that the southern approach to the station be through an unnecessary tunnel. It was later opened out into a cutting.

There were originally separate entrances for each class of ticket. This antiquated practice seems reminiscent of the time when amateur and professional cricketers (known as gentlemen and players) used different changing rooms. Jack Hobbs and Herbert Sutcliffe would open the England innings after coming on to the pitch from different flights of steps.

The station was expanded in 1905 and a new frontage was built. The Luftwaffe bombed it in the Second World War and the roofs were put beyond economic repair – they were replaced by low-level awnings in 1956. Another but far less damaging problem occurred in 1991. This was the flooding of the River Sheaf, which flows under the station. A log that was part of the debris has been placed on Platform 5 to mark the event. Recent years have seen more developments and improvements. These include the addition of a pedestrian bridge connecting the station concourse with the Sheffield Supertram station at the far side of the station.

My experience must surely have been untypical but if my visit is anything to go by the proximity of the supertram, which of course runs on tracks, is capable of causing confusion. A young man asked me if an approaching tram would take him to Leeds and a

few minutes later I explained to two Japanese visitors that a waiting tram would not take them to Birmingham. Both times I accompanied them into the station and pointed out the appropriate platform.

The main concourse contains the usual (for a station of its size and importance) shops, toilets, luggage facilities, cash machines etc, and a helpful information desk. The main station entrance leads out on to the sizeable Sheaf Square. This is mainly pedestrianised and according to Sheffield city council, it provides a stunning entrance to the city centre. Again according to the council it contains the following:

Spectacular Cutting Edge Sculpture, which combines the city's famous resource – steel – with water and light, and a dramatic cascade of water, which uses noise and light to give the plaza an exciting atmosphere.

It is ninety metres long and five metres high at the highest point. It is certainly dramatic, and my photograph of it (taken on a very wet day) accompanies this chapter.

Also Available from Amberley Publishing

Paperback
180 illustrations
96 pages
978-1-4456-1060-3

Available from all good bookshops or to order direct
please call **01453-847-800**
www.amberley-books.com